Diane Borsato

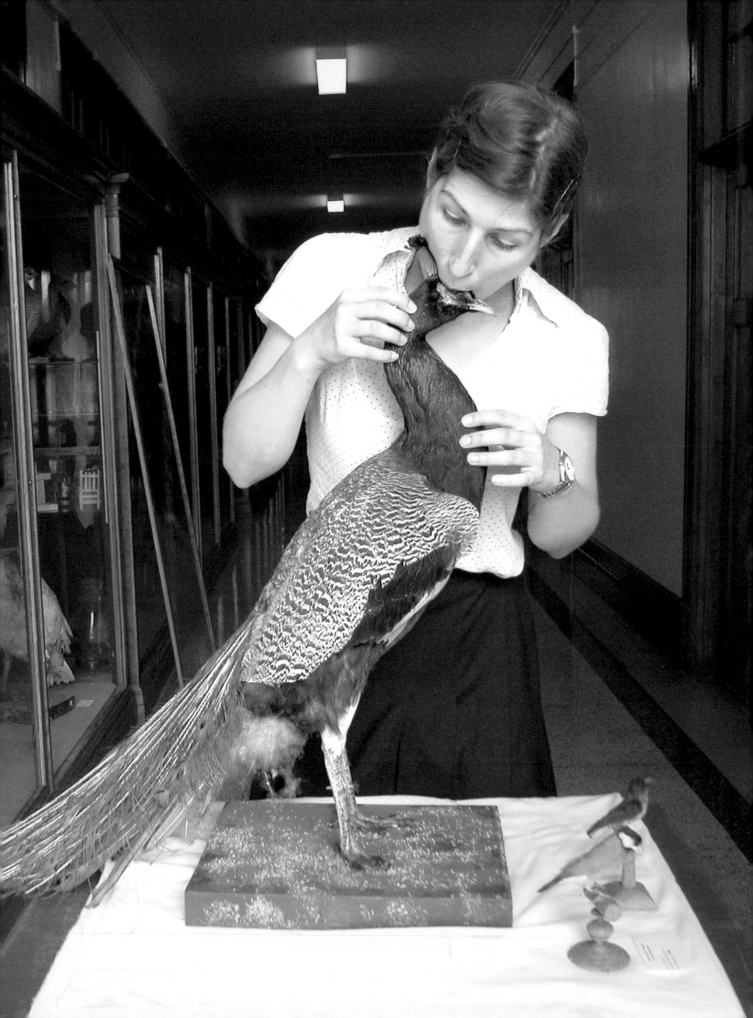

Diane Borsato

With texts by Emelie Chhangur, Darren O'Donnell,
Stephanie Springgay, and Scott Watson

Art Gallery of York University

© 2012 The Art Gallery of York University and authors

Art Gallery of York University
4700 Keele Street, Toronto ON Canada M3J 1P3
www.theAGYUisOutThere.org

Library and Archives Canada Cataloguing in Publication

Borsato, Diane
 Diane Borsato / with texts by Emelie Chhangur ... [et al.].

Catalogue of the exhibition held at Art Gallery of York University, 4 April to 10 June 2012.

ISBN 978-0-921972-64-8

 1. Borsato, Diane--Exhibitions. I. Chhangur, Emelie II. York University (Toronto, Ont.).
Art Gallery III. Title.

N6549.B6843A4 2012 709.2 C2012-901621-7

Exhibition curated by Emelie Chhangur

Edited by Stephanie Springgay
Additional editing and coordinating by Michael Maranda

Designed by Lisa Kiss Design, Toronto
Printed and Bound in Canada by Warren's Waterless Printing

Unless noted here, all photography by Diane Borsato.

Dean Baldwin: pp 10–1, 12 (middle r.), 15, 17
Jesse Birch and Kim Munro for Recorder: pp 12 (all but middle r.), 13
Stacey Sproule and Diane Borsato: pp 44–5
Amish Morrell: pp 46–7, 59, 82, 83 (top), back cover
Tatiana Andropova and Helder Santos: p 53 (lower r.)
Alessandra Borsato: p 60 (top)
Edoardo Borsato: p 60 (bottom l. and r.)
David Blatherwick: p 65
Stephanie Springgay: p 71 (bottom l. and r.)
Swintak: pp 85 (top), 88, 100 (middle r.), 108–09
Terrarea (Janis Demkiw, Emily Hogg, Olia Mishchenko): pp 95, 100 (top l., bottom l., bottom r.),
101 (top l., bottom l., bottom r.)

Botanical Illustrations by Lilly Chan: pp 80–1

The Art Gallery of York University is supported by York University, the Canada Council for the Arts,
the Ontario Arts Council, and the City of Toronto through the Toronto Arts Council.

This publication has been generously supported by the Social Sciences and Humanities Research Council.

Inside

PROJECTS

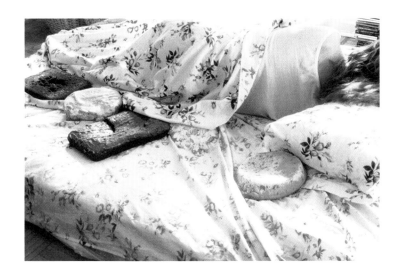

Sleeping with Cake

I was lonely and wondering if sleeping with comfort food might comfort me. So I baked and bought several different cakes and slept with them for an entire night.

The action was one in a series of eccentric experiments performed in my apartment. Other works in the series included *The Broth*, where I boiled sentimental objects to make a broth in an effort to distill the essence of sentiment.

Performed in a downtown apartment in Montreal, 1999.

The Knowing of Diane Borsato

Philip Monk – Director of the AGYU

Our four writers have surrounded Diane Borsato, as if from all sides, each separately taking her as a partner in the collective dance of a quadrille. But if rather in the trick-taking card game of the same name, each also attempts, on the one hand, to touch the artist intimately or, on the other hand, to prod her humourously. Needless to say, Diane has brought this on herself.

To touch and prod, of course, are two degrees of intimacy, though the former might be more welcomed than the latter. Nevertheless, prodding is its own form of inquisitiveness … and Diane's work is all about knowing, after all, however unconventionally it may proceed to acquire its knowledge. In the wanting to know of our authors, intimacy seeks to merge; prodding wants to play along.

So perhaps it is no surprise in reading the four essays that follow that none is a conventional enquiry into an artist's work. But it is curious, however, that the authors have taken *sides* in *knowing* Diane Borsato—knowing the work from the outside or the inside, so to speak. This is no judgement, only an observation I make following Scott Watson's perhaps tongue-in-cheek statement that "knowing is basically taxonomic—looking and naming." For it is Stephanie Springgay and Darren O'Donnell who are advocates for the intimacy of touch and who, at the same time, as an academic or an artist, advocate on Diane's part for the "politics" of her work. Meanwhile, Emelie Chhangur and Scott Watson engage in a participatory mimetics that occasionally finds humour in the situation, partly by slyly poking fun at the artist. Yet, these two, curators both, show themselves in earnest by assuming in their writing a genre form that adequately reflects their serious participation in Diane's projects. Each "side" has chosen to accompany Diane in their own way, an allowance the artist permits.

Since 1999, Diane Borsato has been active, exhibiting widely in Canada and internationally. She might alternately be described as a performance artist, an interventionist, or a relational aesthetician. None of these, though, adequately express the subtlety, intimacy, and, often, wry absurdity of her work. The artist proposes alternate forms of knowledge and processes of learning that are eccentric—yet mundane—researches into the forms of experience and boundaries of everyday life. Her art is a permission to experience differently, generously including the viewer in its delicate persuasions. If we think that we have captured Diane Borsato in our writerly quadrille, we'd be wrong. There is always room for other dancers.

The Art Gallery of York University is pleased to present Diane Borsato's first survey in a public gallery and to be the publisher of the first monograph on her work.

Rolling on the Lawn
at the Canadian Centre
for Architecture

I was living near the Canadian Centre for Architecture and passed by it every day. Instead of walking, I decided to roll across the length of the famous lawn as a new way for my body to be engaged with the city.

The lawn struck me as a provocative space: between the museum and the sidewalk, and between art and life.

I repeated the action in every season for the following year.

Performed without permission on the lawn of the CCA in Montreal, 1999–2000.

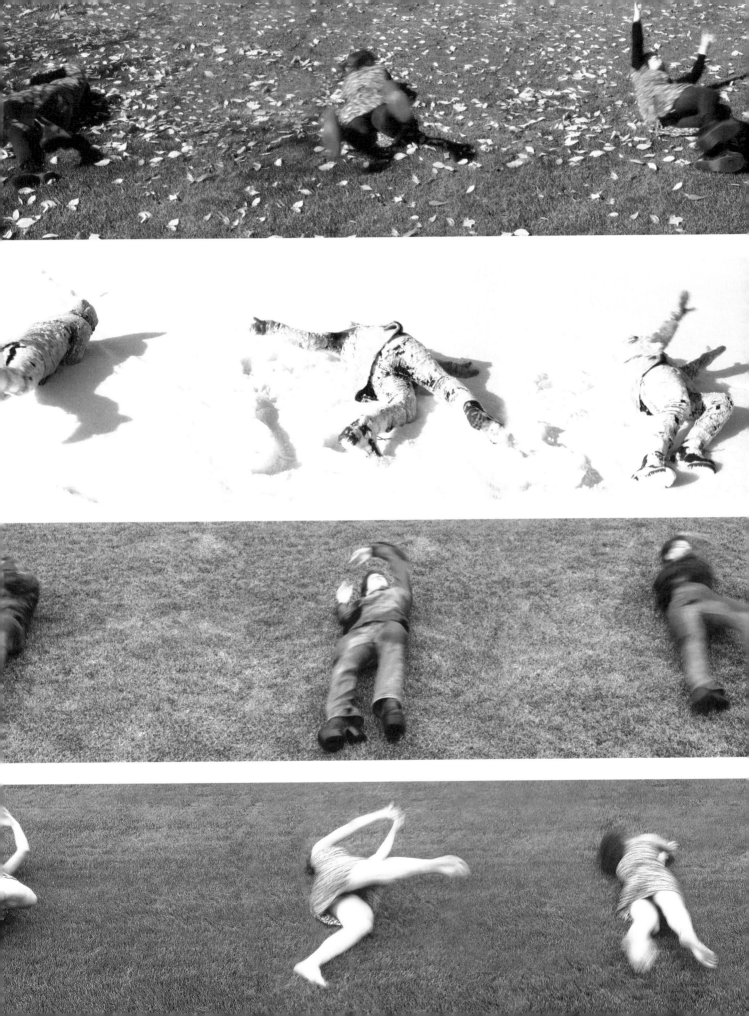

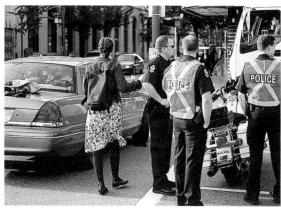

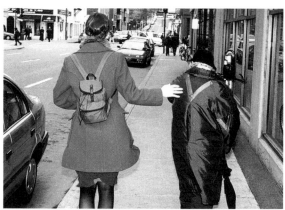

Touching 1000 People

For a month I went out of my way to gently bump, rub past, and tap one thousand strangers in the city. I touched commuters, shoppers, cashiers, museum patrons, and taxi cab drivers.

The exercise was like a minimalist performance. I was exploring the smallest possible gesture, and how it could create an effect in public.

Performed for one month in various locations in Montreal, 2001, and repeated for Artspeak for ten days across the city of Vancouver, 2003.

The World's Longest Paper Clip Chain

I organized an attempt to break the Guinness World Record for the longest paper clip chain. Sixty people performed the rigorous and repetitive action of linking more than a million paper clips for twenty-four continuous hours.

After the public performance of constructing the record-breaking chain in the gallery, the massive glittering field of paper clips was on display for the duration of the exhibition.

Performed at Skol in Montreal, 2001.

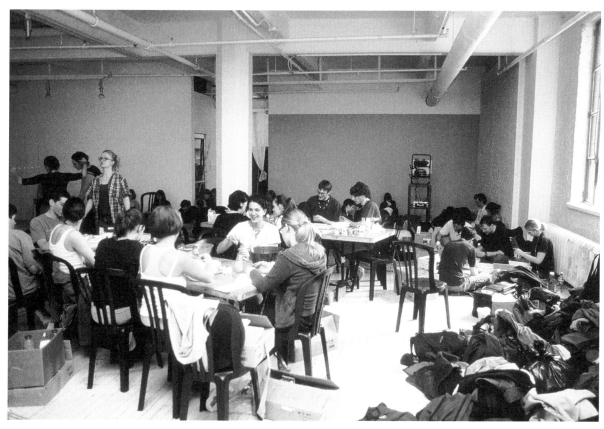

Videos about Plants

Videos about Plants is a series of short videos including *Teaching a Plant to Locomote*, *A Plant Teaching Me to Eat Light*, *Consulting the Plants*, and *How to Kill a Cactus*.

The videos propose how plants as subjects could challenge the hierarchy among species, perform tricks, and give advice.

Shot in apartments in DUMBO and in Carroll Gardens in Brooklyn, New York City, 2002–03.

Carrying my Heavy Bag

I was living alone in New York and discovered that if you happen to get out of a taxi in front of a luxury hotel, porters will offer to carry your heavy bags.

I deliberately presented myself in front of the most expensive hotels to have my burdensome knapsack carried in and then carried out again. I repeated the intervention in several locations.

Performed at The Plaza Hotel, The Waldorf Astoria, and various other locations in New York City, 2002.

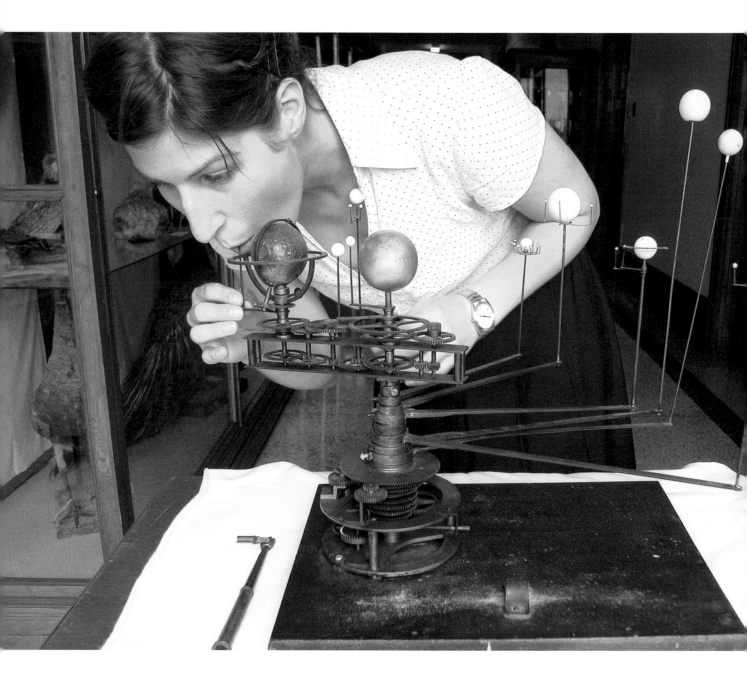

Artifacts in My Mouth

I was given permission to put museum artifacts in my mouth. With the technician, I opened the vitrines and was allowed to experience the objects with my tongue, lips, and sense of smell.

Amongst other things, I was permitted to put a peacock's head, an Egyptian statuette, a lasso, an unknown bone, and a model of the moon into my mouth for a brief period.

Performed at the Museum of Ste. Hyacinthe, for Expression Centre d'exposition de Saint-Hyacinthe in Quebec, 2003.

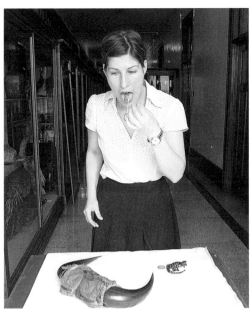
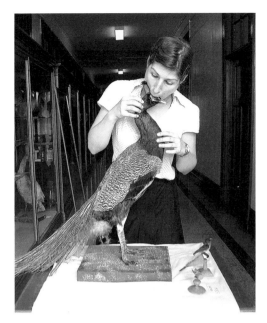
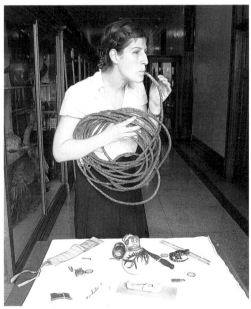
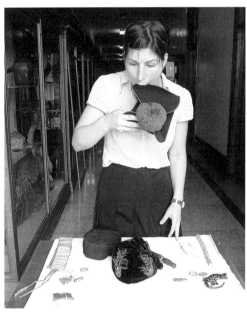

Eating Light Among the Plants

I was on a residency at a Quebec seminary and couldn't communicate with anyone. I discovered a hall garden maintained by one of the priests and decided to spend a day with the plants.

I sat as still as the ferns, the philodendrons, and the palms in an effort to emulate their grace.

I stayed by the window from dawn until dusk, eating nothing but light.

Performed at the Seminary of Ste. Hyacinthe, for Expression Centre d'exposition de Saint-Hyacinthe in Quebec, 2003.

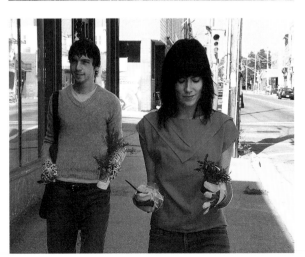

Moving the Weeds Around

In response to an invitation to make a community art project, I attempted to create a collaborative feat that would accomplish as little as possible.

I dug up weeds from neighbourhoods across Halifax with more than twenty volunteers. We mixed-up and traded the weeds at the gallery and then re-planted them randomly all over the city.

Commissioned by Eyelevel Gallery in Halifax, 2005.

Diane is my friend

Darren O'Donnell

During the preparatory workshops for projects with children and young people that my company *Mammalian Diving Reflex* initiates, we present the works of a number of artists whose work shares a conceptual tightness that the kids find very appealing. But make no mistake, we're not pandering to a notion of children as childish; the works we share are complex, often aggressive, critical and filled with quirky, dark humour. The kids are mesmerized and fully appreciative of these artists: Francis Alÿs, Marina Abramović, Santiago Sierra, and Diane. The kids' fascination with this stuff has shaped my own critical criteria, creating a type of work that I now consider 'the best;' works that speak across generations, sparking multivalent readings, that delight, confuse, and demand a consideration of the world that is challenging, deep, and ethical and ultimately setting a very high bar with respect to living life fully. The kids are blown away by the fact that Diane walked around touching 1000 people, immigrated weeds from one neighborhood to another (the kids are often the children of immigrants, if not immigrants themselves), hired dancers to carry buckets of snow accompanied by trumpets, presented tangoing cops, pushed her beleaguered father to keep a ball aloft (full thumbs-ups from the kids for that one!), scored the architecture of buildings for the piano, staged humiliating falls at a fancy gala, slept with cake to cure loneliness, and inserted museum artifacts into her mouth—a project about as kid-friendly as you could hope to find.

There is a false dichotomy, causing a considerable degree of anxiety, in the genre of art variously called relational, social, littoral, or dialogical—a dichotomy that forces artists to polarize and stake a claim either on the ethical or aesthetic end of an illusory spectrum. Those claiming to want to change the world—frustrated by either a modernist avant-garde elitism, which confounds an easy apprehension to escape the constraints of bourgeois society (or something like that) or, on the other hand, a high level of conceptual dazzle and rigour that is, at it's core, bloodless—organize themselves into the ethical corner as committed do-gooders. Then there are those who insist, if not on art's social autonomy (*no one* can do that anymore), then at least on the right of the artist to not have to be instrumentalized by the social economic state. The pejorative 'social work' is now just about the biggest dis you can level at someone who prefers to be judged on the aesthetic value of their artistic production.

There is much addled confusion here and contradictions abound; autonomy is at risk and art always has to deal with some damn issue for no other reason than to get funding or, from the other side, the risk of a lost heteronomy, art can be cleaved from any social function at all, floating meaningless, gasping for air, relevance, if not for box office.

I'm very vocal on the ethical end of the teeter-totter, while Diane snuggles next to me, hers a stealth utopianism, deploying lattice-like aesthetics, delicate and complicated structures. She grimaces but smiles diplomatically at politically correct directives, heavy-handed

polemics, and the arrogance of artists who think they know better. My strategy is to shrug and say fuck it, I'm a social worker, a public servant paid to do the state's bidding to make this place easier to deal with, the whole arrangement resembling to me a complex game of positioning, framing, and illusion. But this teeter-totter is something we both find ourselves occupying reluctantly, forced to polarize, to locate ourselves in a debate made by others so that we can understand our practice and be present in the world of art, taken up by others, the effects of our efforts resonating beyond the intimate circles we both occupy. It's the love, belief, and dedication to the power of intimacy where Diane and I most tightly overlap.

It was Diane who was the first to notice that *Haircuts by Children* was not about anarchy but intimacy; it was a decisive observation that has guided us into future projects and has become one of the constituent particles at the core of the project, if not the company. Diane looks to intimacy even more so; she is the real deal, with a dedication to autonomy as an institution, as a gilded idea, a directive protected from other directives in order to secure a space where she can locate an ethic that is not only for show, not only for public consumption, not a spectacle that she does to dazzle others but, instead, an intimate privacy shared with others. If you were so inclined, you have to acknowledge that the art-into-life strategy does involve disappearing into not just any life, but a capitalist one, a capitalist one that is more than happy to do this, particularly in Floridian initiatives that transform the city into a vibrant mall. Seen in this light, the contrasting idea of an art-for-art-sake seems almost critical yet still doesn't escape commoditization.

Social practice people point to the fact that, since there is no object, there is no commod-ification. But hold on a minute, that's the fetishism trap, with the mistaken view that value is in the commodity when in reality it's actually in the social relations surrounding the production of the commodity. Social practice, relational aesthetics, etc., does run the risk of an easy commodification, a pure commodification: the commodification of social encounters. Bummer!

If we must talk like this, and, unfortunately, at some point, we must, Diane's work is political. Exploring empathy, sensitivity, the boundaries around disciplines, and nature literacy are pretty damn pro-social projects; all of it ethical and deeply political feminist projects. For me, her work is about registering sensation with hyperawareness and thoughtfulness, as if living life were always about tasting. She once told me that she ate a piece of fleur du sel chocolate and it tasted so wonderful that she began to cry. Now, I regard that as beyond nutty, but do appreciate that I have a friend who registers degrees of sensation with such precision that a rare piece of chocolate is going to bring her into contact with this sort of intense joy. I pause for a second, and think about what tends to make me cry and note that it's never related to joy but usually occurs when I've lost some very crucial item in the mess of my apartment and I'm late for an important meeting. When she gave me some of this chocolate, I quietly paired it with a jujube and promptly forgot about both of them once they were in my mouth.

Three Performances (After Joseph Beuys, Marina Abramovic, and Bonnie Sherk) (2008) features Diane and her cat chilling at home and, in all earnestness (is there any other kind

of cat?), reproduces three iconic performances, unplugging the heroic gestures and domesticating them with aplomb, leaving them scattered behind her, flipped, the original works feeling now like parodies. To tussle with your cat feels so much more meaningful than the ridiculous encounters with a coyote, or snake, or lion. We've moved on from those heady days when artists were aesthetic bungee jumpers. There's no need to make such a fuss, particularly when it's the making of the fuss that so clearly was snapped up by ad agencies, movie-makers, and others keen to mobilize imaginations primarily for profit. To make a fuss these days is to decidedly keep it outside that realm, no easy task when a laughing baby is apt to generate millions of hits on Youtube.

Diane is wandering away, very deliberately and methodically pursuing her bees into the forest, struggling to speak Italian with the beekeeper, and establishing friendships with mushrooms. She is sneakily and surreptitiously stepping away from overt and easily instrumentalized displays of social function, something that art is expected to do, but unlike attempts to avoid social function while still producing a work of art, entering back into function, she really is attempting the old art-into-life trick. If relational aesthetics is about relations, then Diane is flirting with the post-relational. Her sphere feels more to be within even more intimate circles: her senses. She makes work that is secret and hidden, taking this art-into-life brief quite seriously. Her practice disappears. She is the scientist in a lab attempting to produce objective data. Two notions of the avant-garde linger; those who want to dissolve art and life, yielding new forms of collective experience, and those who want to create new sensations, producing work that decidedly remains art while challenging what art is. Diane's located in camp A, but without an eye toward affecting a political collectivity —repulsed by it, even—her assertion of autonomy is much more resonant with camp B. She prioritizes her own realm of experience and sensation, seeing things not differently, but fully, yet not particularly dedicated to forming new collectivities, new ways of being together, this being such an abstract and slippery objective. Ultimately, she deploys sensory and emotional sensitivity as a kind of literacy, one that produces knowing, caring, and empathy.

Now would be a good time to introduce the word 'community,' as an abstraction that is well outside Diane's practice. Sort of. Within the arts, 'community' has been deployed by social economic proponents as a code word for the marginalized, excluded, racialized, and poor. Community arts, then, brings with it a thoroughly non-autonomous connotation, of artists who have abandoned their autonomy to help out the children in the 'hood,' for political and ethical reasons first and foremost or, worst case scenario, to make a publically or foundationally granted buck. I do both. While we wait for the term to be rehabilitated—a project that a bunch of us are fully dedicated to—we need to deploy more precise words. Instead of 'community,' Laurie McGauly, founder of Sudbury's *Myth and Mirror's Community Arts*, proposes Miguel Abensour's idea of friendship,[1] a concept that cannot be so easily romanticized and is an easily quantifiably entity; you know who your friends are, but who the hell is your community!

One of the problems with all of these different ways to understand art and its relation to how we are to be together in the world is that they examine the work that the artist *produces*, categorizing the forms of production a given artist deploys; are they indulging in an irresponsible conviviality, a democratic antagonism, a dialogical interplay? The focus in

all of this is not only always on the methods of a given artist, but, in addition, critics point to particular works to exemplify the various points they are making, the idea of the artist, the individual, an organic whole, a totality, whose body of work and working methods reveal their allegiance, blind spots, aspirations, successes, and failures. The problem with all of this is that it's just not how life *is*. There is no such thing as an individual artist as such, or, if there is, they're so far off in the woods that to speak of them tripping and falling is to ask whether or not their collision with the ground will actually produce a sound. The moment their work can be spoken of, they cease to exist as an individual artist. Diane is currently about as much in the woods as you can be, but she is still very audible, crashing around in a cloud of bees, honey dripping off her chin, her fists full of mushrooms.

Diane's work, while important in and of itself, should not be seen in isolation. Her investigations must take into account the people around her who form her research team, artists who she has invited into her life and fed good food to, her friends. A quick and incomplete survey reveals a ton of great culture heads: Amish Morrell, Cynthia Loyst, Jason Tan, Hazel Meyer, Julia Loktev, Swintak, Sandy Plotnikoff, Joanne Hui, Jamie Shannon, Dan Young, Stephanie Comilang, Don Miller, Olia Mishchenko, Emily Hogg, Janis Demkiw, Emelie Chhangur, Dean Baldwin, Katie Bethune-Leamen, Dave Dyment, Roula Partheniou, Laurel Woodcock, Sandra Rechico, Jon Sasaki, Elaine Gaito, Shawn Micallef, Michael Cobb, Karen Azoulay, Jo-Anne Balcaen, Peter Hobbs, Paul Litherland, Karen Trask, Aislinn Thomas, Michael Maranda, Jessica Wyman, Maggie Groat, Anne-Marie Ninacs, Massimo Guerrera, Corine Lemieux, Joel Silver, Christine Shaw, Sameer Farooq, Annie MacDonell, Arthur Renwick, Aurora Browne, Bruno Billio, Cecilia Berkovic, Charmaine Wheatley, Christof Migone, Samuel Roy-Bois, Cory Lund, Derek Sullivan, Doug Jarvis, Eve K. Tremblay, BGL, Fastwürms, Iga Janik, Jim Drobnick, Jennifer Fisher, Kali Birdsall, Kim Simon, Kristan Horton, Laura Swan, Stuart Mullin, Margaux Williamson, David Blatherwick, Michael Bartosik, Duncan MacDonald, Adrian Blackwell, Jane Hutton, Stephanie Springgay, Shie Kasai, Suzanne Carte, ... etc.

It's here, then, that Diane's practice takes on the deepest of its meanings and intimacies. Even if she were to become a full-time beekeeper, she would still be part of this consortium of artists, she would be feeding us and provoking our senses. Diane, more than most artists, should be not be judged solely on the work she generates to share with an indeterminate and wide public but for the component she is and the role she plays in an ad hoc but tightly interlocking congress of culture producers, the connection to these people being first and foremost one of friendship, her influence in their lives deeply material, and quantifiable. Her observation about the intimacy of *Haircuts by Children* has been an artistic contribution to my company, and my work, which has literally restructured our entire apparatus of intention. We owe Diane a royalty.

So with friendship, we have a concept that is entirely concrete, material, and more or less quantifiable, and you know when they cease to be your friend, and you know when that friendship is on rocky terrain. It's through friendship and only through friendship that community is possible and, for those of us who have allowed ourselves to be instrumentalized toward social work, friendship offers a method for generating the other vague abstractions like 'empowerment' and 'engagement.'

I'll let my friend, Laurie McGauley do the heavy lifting:

> Abensour claims that utopia doesn't belong in the realm of the understanding—
> the laws of society—or in the realm of knowledge—the laws of history. But he doesn't
> follow the Romantic's path to situate utopia in the aesthetic realm. Rather, utopia
> belongs to the realm of human encounters, within the relations between people.
> Not in the assumption of a predetermined idealized 'common sense,' but rather
> in the unknown, undetermined territory between people as they are as individuals.
> Removed from the realm of knowledge and reason and situated in the relations
> between humans, Abensour concludes that utopia is necessarily an ethical project. [2]

In this way, Diane's project is a deeply ethical project. Hers is not homogenous conviviality, nor is it an antagonist rehearsal of social disparity, nor is it an open dialogue to produce understanding. Diane's is a stealth utopianism, one that primarily grounds itself in the full appreciation of what the senses have to offer as, perhaps, the only clean and unencumbered realm and to circuit them into the world, via friendship. To spend time with Diane is to hear constantly about how things taste. She wants to put the world into her mouth, looking to read life's complexity through her taste buds, and feeding it to her friends. If a photo happens to end up on a gallery wall—bonus.

Notes

1. Laurie McGauley. "Utopian Longings:
 Romanticism, Subversion, and Democracy in
 Community Arts" (Masters thesis, Laurentian
 University, 2006).
2. Ibid., 95.

None of the ideas are mine. I've ripped off:

Claire Bishop, "Antagonism and relational aesthetics," *October* 110 (2004): 51–79.
Claire Bishop, "The social turn: Collaboration and its discontents," *Artforum* (February 2006): 179–185.
Nicolas Bourriaud, *Relational aesthetics* (Paris: Les Presses du réel, 2002)
Kim Charnley, "Dissensus and the Politics of Collaborative Practice," *Art & the Public Sphere* 1:1 (2011), 37–53.
Gail Day, "The Fear of Heteronomy," *Third Text* 23:4 (July 2009): 393–406.
Sarah Kanouse, "Tactical Irrelevance: Art and Politics at Play," *Democratic Communiqué* 20:2 (1997): 23–39.
Miwon Kwon, "One Place After Another: Notes on Site Specificity," *October* 80 (Spring 1997): 85–110.
Laurie McGauley. "Utopian Longings: Romanticism, Subversion, and Democracy in Community Arts"
 (Masters thesis, Laurentian University, 2006).
Sal Randolph. (2010). "Let's Blush," *127 Prince* (26 August 2010). Retrieved 12 April 2011 from
 http://127prince.org/2010/08/26/lets-blush-sal-randolph/
Stewart Martin, "Critique of relational aesthetics," *Third Text* 21:4 (July 2007): 369–86.

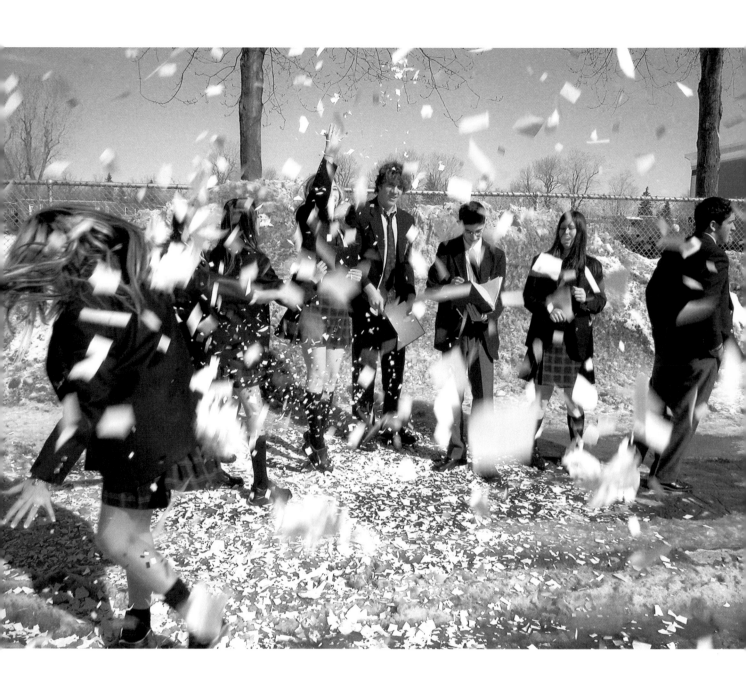

The Winter Drawings

As part of a community intervention project, I worked at two diverse neighbourhood schools directing the students to enact conceptual instructions for sketchbook projects.

The resulting works—such as *The Winter Drawings*, where students ripped drawing paper into small pieces and tossed them into the air like snow, and *The Kilometre Drawings*, where students cut and taped strips of drawing paper to form a ball consisting of one continuous kilometer—manifested themselves in various performances and sculptures. The actions and objects were documented and exhibited as a series of photographs.

Commissioned by the Saidye Bronfman Centre. Performed at the Marymount Academy, and Lower Canada College in Montreal, 2005.

Wondering How Long He Can
Keep Up the World

My father is an avid soccer player and fan, so I asked him to perform with a soccer ball designed to look like a globe for a video. I wanted to see how long he could keep the ball in the air by "juggling" it with his knees, feet, and head.

In the video we are heard negotiating everything from the terms of performance art to international relations. I pushed him relentlessly to continue "keeping up the world" until he quit, exhausted and dripping with sweat.

Created for TRAFIC Inter/nationale d'art actuel in Abitibi-Témiscamingue, Quebec. Shot in Mississauga, Ontario, 2005.

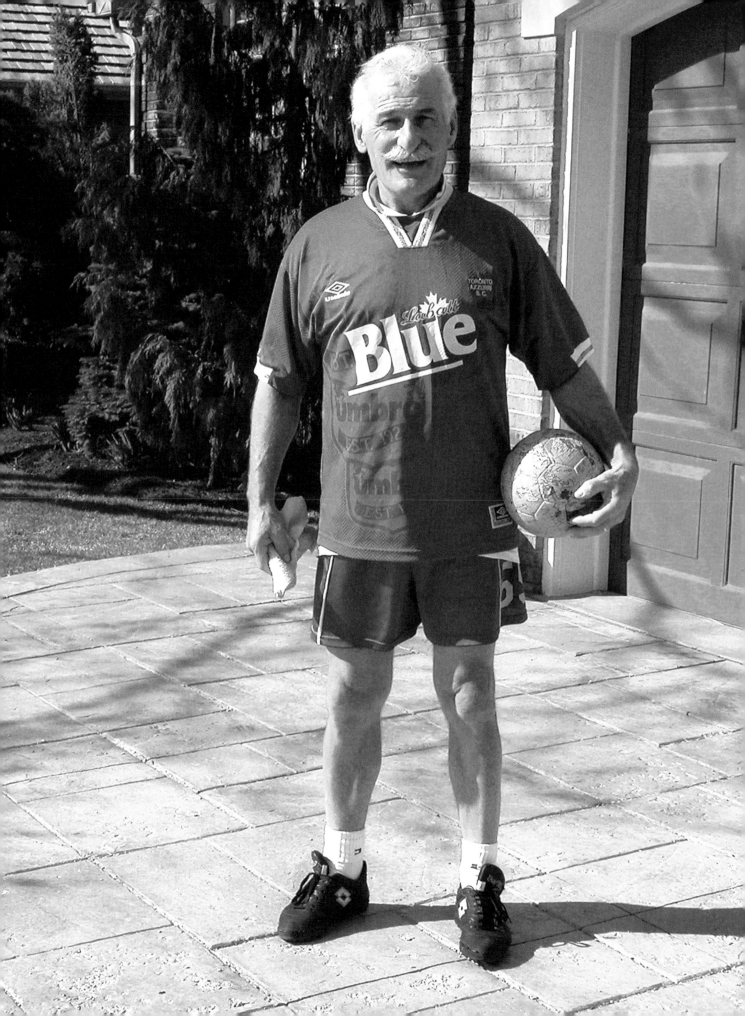

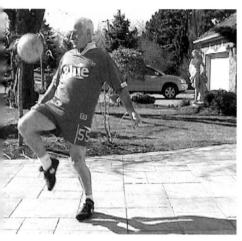 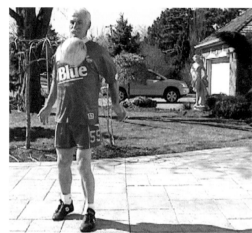 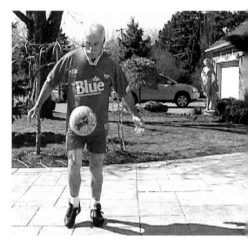

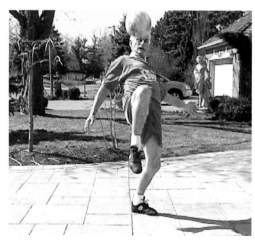 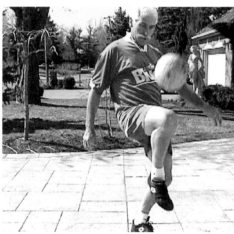

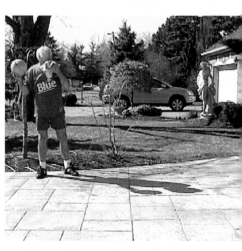

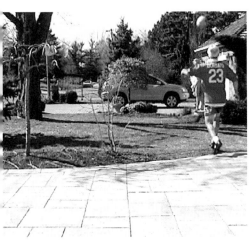

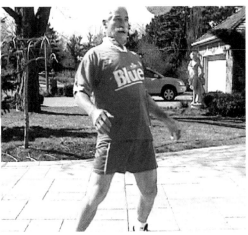

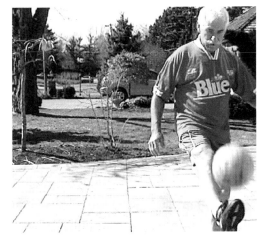

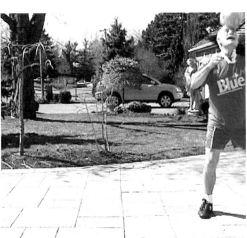

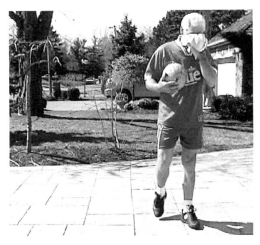

Snowballs

I packaged a dozen fresh snowballs and the tools for their reconstitution in France. The attached drawing instructed that the snowballs should be thrown at people, animals, and property. The piece was mailed to Paris during the 2006 suburban riots.

Commissioned by the Museum of Time in Besançon, France. Assembled in Toronto, 2006.

The 'Liveness' of Pedagogy and the Politics of Touch in the Work of Diane Borsato

Stephanie Springgay

Trudging through mounds of melting snow, Diane leads a group of amateur mycologists on a walk, taking stock of the various mushroom species available in the numerous shops in Chinatown, Manhattan. With field guides in hand, the naturalists search for and identify fungi species in a playful twist, bringing into collision Westernized knowledge of mushrooms and the culturally specific commodities sold in many Chinese shops.

In Italy, Diane once again works with a group of specialists—this time apiarists and their families. Immersing herself into beekeeping and the Italian language, she teases out the different stages of bee development, the structure and cycle of a bee colony, colony reproduction, and harvesting while simultaneously enveloping herself with the couplings of the 21 letters found in the Italian language.

On a farm near Shelburne, Ontario, Diane constructs the *Walking Studio*, which over the course of a summer becomes home to a number of different artists. As people congregate around the wooden table or sweat it out in the semi-circular sauna, the *Walking Studio* functions as a site of hospitality, a space of unconditional welcome and collectivity.

Over the past number of years I have experienced a number of Diane Borsato's relational in(ter)ventions—mycological forays, stargazing, tango dancing, Italian lessons, apiaries—as intensities of composition that enable other ways of thinking about bodies in movement. My participation in, learning with, and writing alongside Diane's proliferating gestures is marked by an urge to re-conceptualize pedagogy. Concerned not with a pedagogy of consensus or procedural models, I consider Diane's work (and thus pedagogy) as the 'capacity to learn' through the vitality of bodies coming together in movement. This 'liveness' of pedagogy, where teaching is no longer the communication of a teacher's skill or prior knowledge, is a sensational and affective event where we are all invented in the process. In this sense, pedagogies are made rather than prescribed or predicted.

In this essay, I consider Diane's work through Deleuzianguattarian conceptualizations of the processual, sensing body. Despite the historical positioning of the senses taste, smell, and touch as innate and natural, and thus deemed insufficient, subordinate, and too vulgar to be part of the construction of the rational subject, the senses are often viewed as being controlled by a stable and unified body. I want to challenge these assumptions by positioning the senses relationally—as expressions of moving bodies.

Specifically, I return to a consideration of Diane's work through a politics of touch.[1] Not simply a touching akin to skin on matter, but touch as "the act of reaching toward, of creating space-time … when bodies move."[2] Touch is conveyed in the action of one hand

touching another, fingers gently carving a mushroom out of the earth, bodies in the embrace of a tango, fingers scratching a chalkboard, tasting museum objects, wrestling with bees, or through the labor of moving vast amounts of melting snow on public transit.

Touch is also the opening of one body to another; it is an interval, an event. Giorgio Agamben relates touch to a gesture which is asignifying when he states, "because being-in-language is not something that could be said in sentences, the gesture is essentially always a gesture of not being able to figure something out in language."[3] A politics of touch is not simply about putting bodies in contact with one another or with objects rather, it foregrounds the senses and implies a political engagement that is flexible and unpredictable. This is not a politics based on laws, governance, or the rational subject, but a politics in which the gesture, the reaching toward, evokes a directionality, displacement, disruption, dis-agreement. This is a politics of expression, not representation. My intention, in turning to a politics of touch, is to think experimentally about pedagogy, engendering a shift from trying to 'know' something in order to 'teach it' to an engagement with learning as an event that has not yet ended.

Although convivial in their articulations—the foraging for mushrooms while walking with friends in a sun splattered forest heady with the mustiness of wet earth or savoring the delicate note of carefully extracted honey—Diane's explorations extend beyond merely agreeable gestures. It is through touch that, as Erin Manning states, "a political moment is exposed, a moment of transition, a moment of incomprehensibility."[4] In touching, the body senses, dissents, and consents—"because to touch…is to allow myself to be touched by touch…by the 'flesh' that I touch and that becomes touching as well as touched."[5]

Take for instance her video work, *You Go To My Head,* in which a man and woman, hus-band and wife, attempt to sing by drawing breath from the other's lungs. As the video and song proceed, the woman and then the man are both supported and then depleted as they struggle to fill their lungs. If we think of touch not simply as the static act of mouth to mouth, but as a reaching toward in movement, then the "politics of touch evokes…a displacement that produces affinities, attractions, mirages, magnetisms and divergences, ruptures, fissures, and dissociations."[6] In the sequence of breathing and singing the encounter between bodies demands constant awareness, a reciprocity that becomes terribly exhausting (or even life threatening). What makes this intimate and excruciatingly painful embrace political is the unpredictability and reciprocity of touch, of reaching towards that which is unknowable. Each time the singers start over again, drawing breath from the other, is an emergent moment. A politics of touch is not based in excising power but an opening towards—a recognition that I must also be touched in order to touch you. When we think about pedagogy from a similar position, as a body in movement, then we can untether pedagogy in terms of coordinates and methods with a beginning and an end, where change is understood as a modification to these coordinates. Instead, pedagogy in motion becomes open to variation and transformation. The 'liveness' of pedagogy is "an immediate, unfolding relation to its own nonpresent potential to vary."[7] Thus, if we conceive of pedagogy taking place "at the turbulent point of matter crossing into mind, experience into knowledge, stability into potential, knowledge as promise and provoca-tion"[8] then it is in this moment of liveness that the world appears. This appearance however

is neither knowable nor recognizable. Meaning is not guaranteed. Rather, appearance would be engendered in the affect of the event.

Affects are passages of intensity, a reaction in or on the body at the level of matter. Affects are visceral and express our state at a given moment in time and thus are always experienced in time and as duration. For Deleuze, affect is "the becomings of my own body, especially when it encounters another body,"[9] while Brian Massumi describes affect as pertaining "to the dimension of passage, or the continuity of immediate experience."[10] Feminist scholar Elizabeth Grosz relates affect to the sensations impacted on the surface of the body—on cells, organs, and the nervous system. Affects increase our capacity to act in the world, to learn, and to be otherwise directed. While most political thought encourages the coherence of bodies in time and space, Manning argues that politics must begin to think itself as an extension to the body's sensing apparatus. Politics is not beyond the body; it is of the body. Bodies sense and their sensing movements reach toward relations of emergence where expressions are always already incorporated into political texts.

In the relational performance *Sleeping with Cake*, Diane lies restless amidst sticky sweet confections. In *Italian Lessons*, she immerses herself in unlikely experiences—primordial black holes, ping pong, salsa dancing, first aid, and beekeeping—in order to learn the Italian language. These intimate and private gestures streak across surfaces enabling not only new ways of coming to experience, but different ways of thinking, sensing, and expressing.

In her most recent iteration of the *Italian Lessons*, Diane has plunged herself into the world of beekeeping, traveling to Zafferana Etnea, Italy, to work with local apiarists, apprenticing with the Toronto Beekeepers Cooperative at the Fairmount Royal York Hotel, and designing and maintaining her own hive in her backyard. The performances conjure up the intense hum of a swarm of bees coupled with the flowery perfume of the hive—forceful sensations that connect across various intervals. Swarming reminds us that bodies move all the time, composing and decomposing, or, as Manning suggests, "[t]o think politically is to become aware of the surfaces that connect intervals between worlds."[11] Learning about bees and honey, and how not to get stung, while also sliding Italian vowels along your tongue is a pedagogy in movement, a series of gestures that increase the body's capacity, its liveness. Language is no longer simply communicative, but performative. Rather than descriptive, language *does* things. Thus, pedagogy is capable of altering relations, of experimentation, where experimentation is concerned with the not yet known, the new, the interesting, and the remarkable. Deleuze and Guattari refer to thought as experimentation (as opposed to representation). For Deleuzeguattarian thought, thinking proceeds at the same time as it thinks. Thus, beekeeping and Italian are not discrete subjects to be studied, consumed, or represented in art and teaching, but practices that constitute themselves, producing, augmenting, and inventing the world.

Take, for example, Diane's obsession with taste—placing dusty museum objects in her mouth or distinguishing the discerning notes of eucalyptus honey. How might we re-concep-tualize these actions as potential, political gestures? What Diane's interventions do are create spaces for affect—spaces that are needed for bodies to do things differently; spaces that allow the exploration of every event in its singularity. In this way, art and pedagogy

create conditions to invent rather than to discover from a distance. A collective experimentation thus produces spaces where we do not yet know what is to come. "When the logic of affect is activated," Liselott Olsson argues, "it gives rise to collective experimenting, intensity, and unpredictability. It functions like a sort of contagion that people get involved in, or rather 'hooked on'."[12] In the pedagogical space-time of bodies touching, prediction and comprehension—the tautology of learning—are replaced with active potential.

In closing, I turn to the *Walking Studio*, which is the focus of Emelie's essay in this collection. Specifically I consider the *Walking Studio* from the perspective of a problem, or in Deleuze's terms a 'problematic field,' which is not a flat, uniform, or passive expanse, but rather is distinguishable in terms of intensities. When we take learning to be a set of processes that disappear through the acquisition of content, then learning is something that has an already established outcome. Likewise, in contemporary education students are often over-burdened by the constant circulation of information and the pressure to 'know more.' But the learning evoked by the *Walking Studio* can never be predicted, planned, or scripted beforehand, nor can it be evaluated according to predefined standards. Rather, if we consider the ways that Emelie and others inhabited, moved through, and touched the *Walking Studio* as a problematic field, "a field of differentiated but interrelated, intensive singulars that express potentiality,"[13] then learning becomes a complex pattern of relations. A pedagogy of liveness is an approach to learning that opens new passages, new ways of thinking that are outside of regulatory and determined organizations of the body. Diane's intimate gestures offer such openings for the emergence of the new, keeping us moving, inciting us to sense beyond this moment toward another moment.

Notes and Bibliography

1. See Stephanie Springgay, *Body Knowledge and Curriculum: Pedagogies of Touch in Youth and Visual Culture* (New York: Peter Lang, 2007) for a previous discussion on Diane Borsato's work and theories of touch.
2. Erin Manning, *The Politics of Touch: Sense, Movement, Sovereignty* (Minneapolis: University of Minnesota Press, 2007), xiv.
3. Giorgio Agamben, *Means without End: Notes on Politics*, trans. Vincenzo Binetti and Cesare Casarino (Minneapolis: University of Minnesota Press, 2000), 58.
4. Manning, *The Politics of Touch*, 10.
5. Derrida, *Le Toucher—Jean Luc Nancy* (Paris: Galilee, 2000), 312. As cited in Manning, 15.
6. Manning, *The Politics of Touch*, 14.
7. Brian Massumi, *Parables for the Virtual: Movement, Affect, Sensation* (Durham: Duke University Press, 2002), 4.
8. Elizabeth Ellsworth, *Places of Learning: Media, Architecture, Pedagogy* (New York: Routledge, 2005), 165.
9. Cited in Simon O'Sullivan, *Art Encounters Deleuze and Guattari: Thought beyond representation* (Basingstoke, Hampshire: Palgrave MacMillan, 2006), 41.
10. Massumi, *Parables for the Virtual*, 258.
11. Manning, *The Politics of Touch*, 113.
12. Liselott Mariett Olsson, *Movement and Experimentation in Young Children's Learning* (New York and Oxon: Routledge, 2009), xxiii.
13. Michael Halewood, "On Whitehead and Deleuze: The Process of Materiality," *Configurations* 13:1 (2005): 70.

A Series of Minor Incidents

Collaborator Stacey Sproule and I faked several minor accidents in public. We spilled, smashed, and ruptured various containers in restaurants, shopping malls, on the street, on the streetcar, and in supermarkets.

The deliberate "accidents" were documented and exhibited as a slide-show of forty-nine images.

Performed in various locations for FADO in Toronto, 2006–07.

Bouquet

In response to instructions by The Critical Art Ensemble to "commit a crime with a humanitarian outcome," I decided to steal flowers from neighbours' gardens and give the entirely stolen bouquet as a surprise gift to my mother. She was delighted.

Since making the first version of this work, I have made several different vase arrangements of stolen flowers in an ongoing series of sculptures.

Performed in Toronto and the surrounding region, 2006–12.

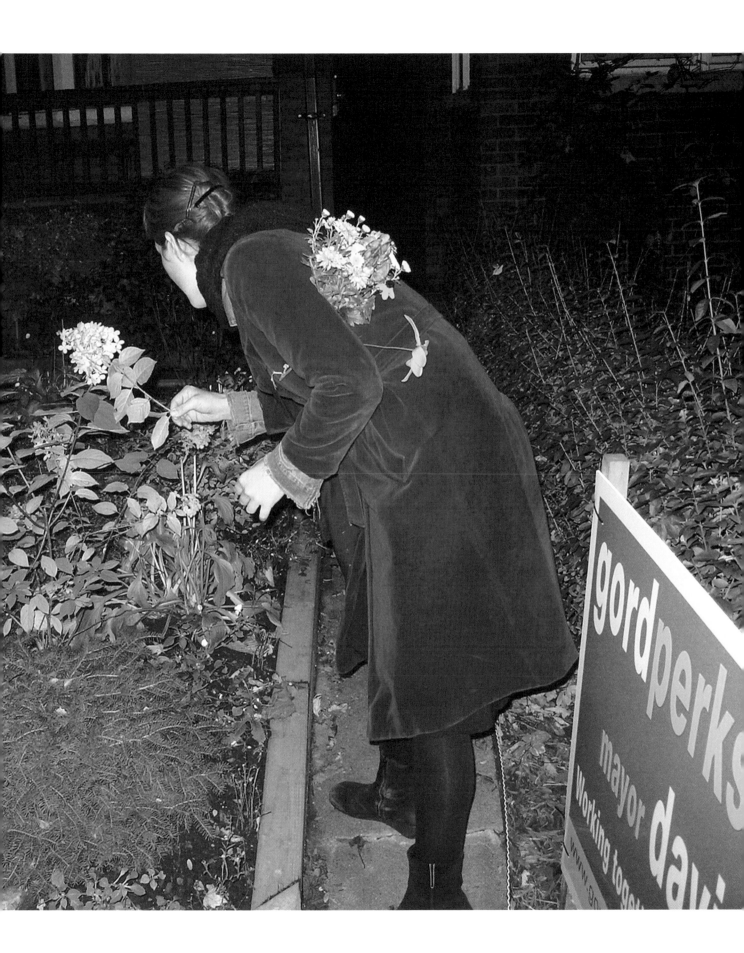

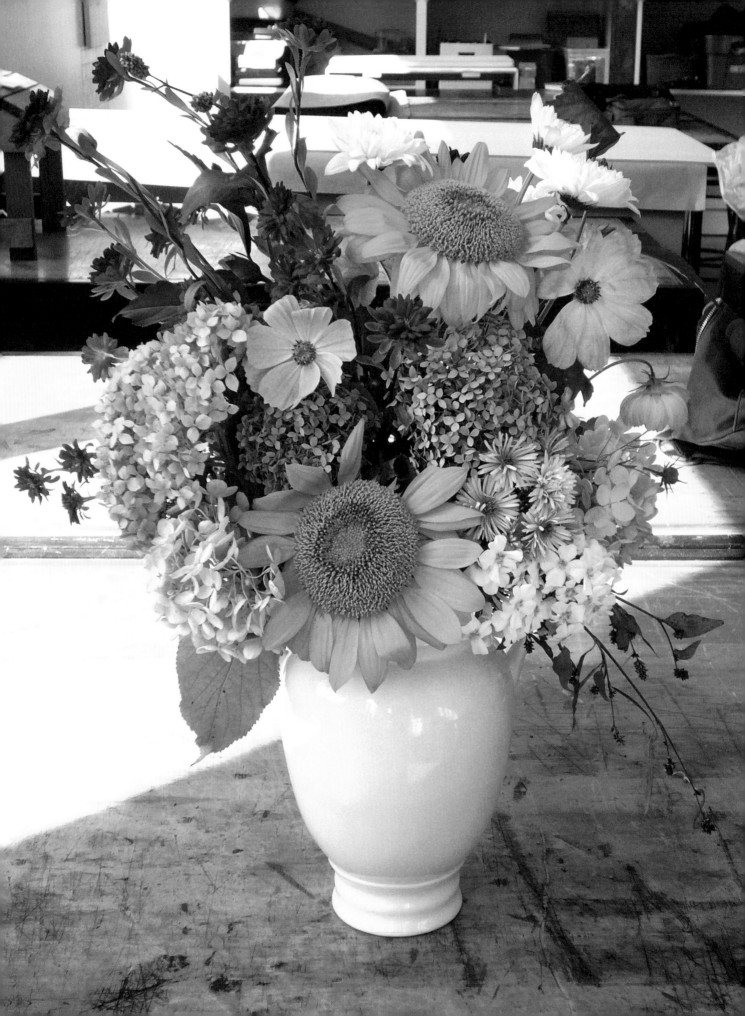

Next Page

Eclipse

I created a billboard image to contribute to
an exhibition of sculpture commemorating
Montreal's Expo '67.

In the image, two women are posing in front
of a giant snowball that appears to eclipse
the iconic Buckminster Fuller Dome created
for the American Pavillion in 1967.

**Commissioned by the Montreal Sculpture
Triennale ARTEFACT in Montreal, 2007.**

How to Respond in an Emergency

For twelve hours through the night, dancers dressed as city police officers were seen in various neighbourhoods dancing an intimate tango with one another. Music was provided by cars parked nearby.

Dancers: **Tatiana Melnyk and Lisandro Gomez, Mario Bruyere and Lisa Romaine, Toni Hrivnak and Joseph Baronka, Diane Borsato and Igor Rasic, Jennifer Leung and Robert Horvatek, and Sergio Smilovich.**

Commissioned for Nuit Blanche in Toronto, 2006.

Skyline

After I moved to Toronto from New York, I started photographing the CN Tower from hundreds of points of view from all over the city. Every time I happened to see the tower, I would take a snapshot with my hand blocking it out— compulsively imagining it gone.

The work consists of hundreds of still images that disorient the local viewer in a similar way that the absence of the World Trade Centre towers disoriented New Yorkers for several years after their destruction.

Collected from various locations in Toronto, 2006–09.

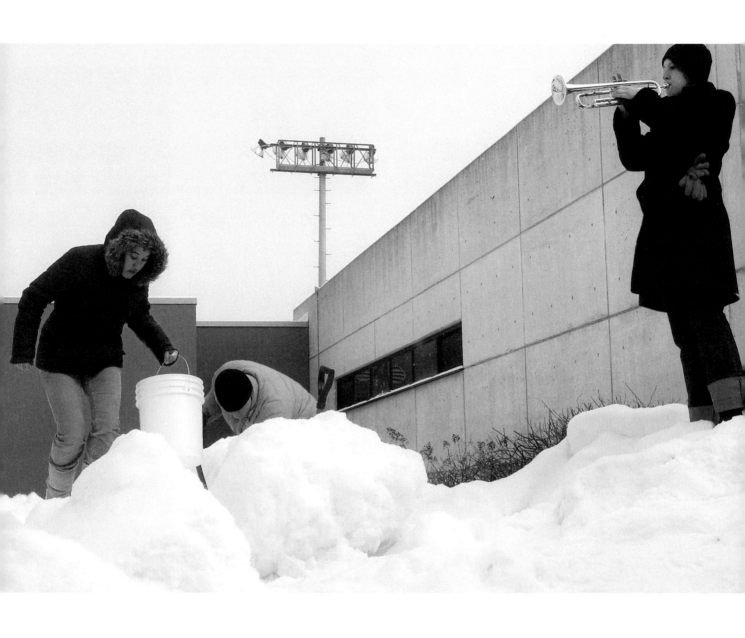

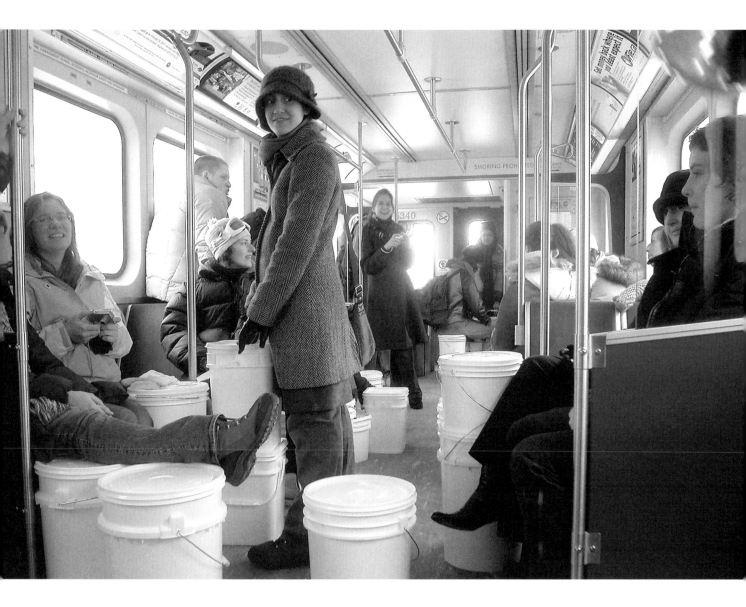

Snowbank

Working from the notion that non-virtuosic everyday movements can be dance, I led a large group of dancers to move a snowbank across the city. We carried dozens of white pails full of snow while travelling by foot, subway, and bus.

The absurd and heroic feat was accompanied by periodic outbursts of experimental trumpet music.

Dancers: **Janina Piva, Ryan Gibson, Amber Landgraff, Kristen Keller, Sarah Douglas, Alex Thompson, Alison Smith, Sky Fairchild-Waller, Danny Jordon, Allison Peacock, Julie Grant, Day Milman, Riaz Mehmood, Nadia Kurd, Liz Knox, Serena Lee, Alicia Grant, Cara Spooner, Nadia Halim, Andrea Roberts, Rhonda Corvese, Diane Borsato, and Amish Morrell.**

Trumpet: **Emilie LeBel**

Commissioned by the Art Gallery of York University in Toronto, 2007.

Italian Lessons

I have always found conventional language courses to be tedious. I decided to try to study a second language indirectly, while trying to learn something else.

I arranged to have lessons in various practical subjects, including ping-pong, salsa dancing, basic first aid, and beekeeping, entirely in Italian.

I invited a graduating physics student to give me an intensive lesson on the subject of primordial black holes, entirely in Italian.

Performed in Toronto, Treviso, and Zafferana Etna, 2007–2011.

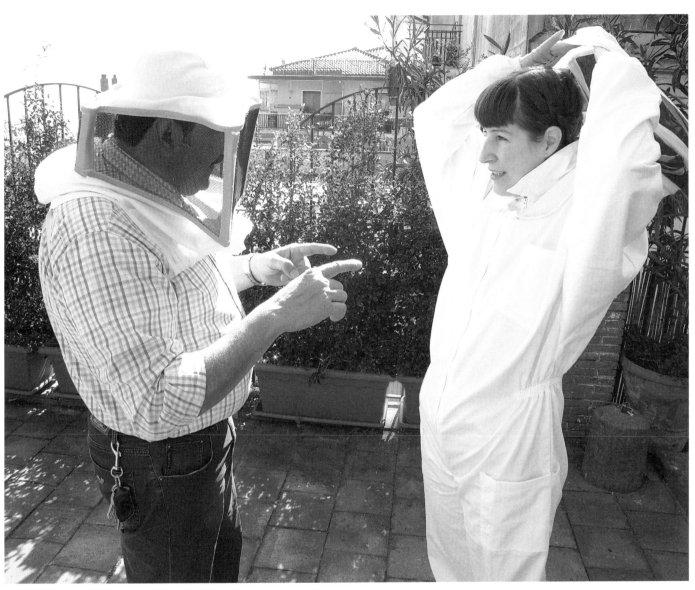

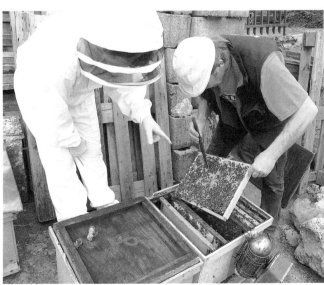

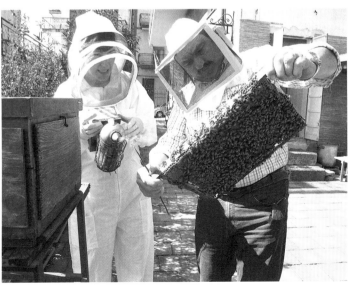

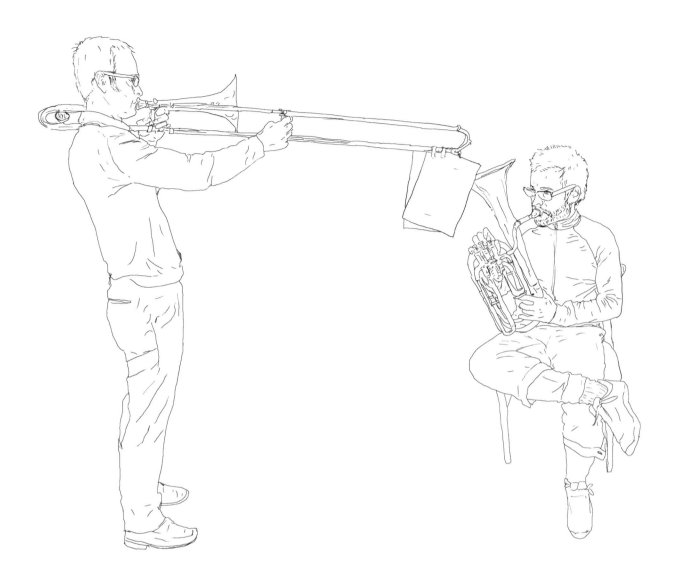

Untitled Scores

I created a series of drawings featuring altered instruments and absurd performance proposals.

Some of the scores showed performers playing the flute with the wind, blowing into two trombones with one shared slide, singing with a dental guard in place, or playing an electric guitar plugged into lemon batteries. Others were more abstract, showing images of icicles, flower buds, or a model of the CN Tower.

Five of the scores were interpreted by Ryan Driver for a performance in Quebec City at L'Oeil de Poisson. The songs were recorded and released as a CD in Toronto, 2008.

Artist Talk

I was invited to give an artist talk and hired an Argentine Tango teacher to give a lesson to the audience instead.

Students and faculty were compelled to practice movements in close embraces with one another. As the teacher's dance assistant, I remained silent throughout the "talk."

Performed for the School of Visual Arts at the University of Windsor, Ontario, 2008.

Subject: Re: monograph text

Scott Watson

From: sdwatson <s******@ubc.ca>
Date: Thu, 25 Aug 2011 15:09:12 - 0400
To: Stephanie Springgay <s******@utoronto.ca>
Subject: Re: monograph text

Dear Stephanie,

I regret to say I failed to write the monograph on Diane Borsato's work. Every start I gave to the writing dead-ended or dried up. I tried revisiting Bourriaud's book on relational aesthetics, a book I continue to find quite useful and provocative, especially as it is so often repudiated. But that did not get me very far. I still think about Diane's piece that I experienced last spring, however.

One of our curatorial students, Shaun Dacey, had included Diane's piece, *Terrestial/Celestial*, in his graduating exhibition. Diane's generosity in working with a student curator was impressive and this generosity is part of her practice and part of *Terrestial/Celestial*. The set up for *T/C* was simple and elegant, locating the work in the body, in time, in nature, in society, and in the cosmos. Diane contacted two groups—the local Vancouver Mycological Society and the Vancouver Centre of the Royal Astronomical Society of Canada—and arranged for an afternoon hunting for mushrooms and an evening gazing at stars, with the two groups demonstrating and exchanging knowledge. This was arranged for a day in May at the University of British Columbia's forest in Maple Ridge, where there is both a demonstration forest and a small observatory. Besides the two groups of amateur scientists, a small group of artists and students also took part. I'd say about fifty or so people in total participated.

Not so usual for Vancouver, and very lucky for the piece, it was a nice sunny day in May when this took place. We convened in the afternoon (I can't remember when exactly, 2 pm perhaps?) at a parking lot in the forest. While we waited for various key players, our mycological guides began to look around and show us what could be found.

It took about forty minutes for all to arrive (some important person with a telescope had been stuck in traffic), after which we were divided into three (I think) groups. I had invited a young acquaintance of mine to join in. He is a recent immigrant from Israel, a gay Jew with a Moroccan background and a camera hound. We joined the group led by a tall man with long silver hair in a ponytail. I'd guess our guide was a very fit 60 plus.

May is not mushroom season, but there are always mycological events in a rain forest. We gathered, sometimes picking, sometimes not. We were told that fungi are actually neither plant nor animal but a 'kingdom' of its own.

Although the things we found were of modest size, and limited in variety given the time of year, there were marvels. My favorite things were small bright orange mushrooms that grew in standing water and the strange fungus that look like a sea anemone under a magnifying glass. Being in the forest for hours, looking intently at the ground is a pleasurable exercise, and so is being with a group of people, many of them strangers to each other, engaged in a pursuit that is about experiencing and knowing. The knowing is basically taxonomic—looking and naming. This is what a mycological field trip is primarily about, like bird watching I guess.

Our guide was asked several times if a particular specimen was edible or psychedelic. He handled these questions with good humoured disdain, as though these were the minor and not so consequential things one needed to know about a mushroom, the kind of things that don't really interest a mushroom lover. To judge books by their covers, however, I was pretty sure that the mycologists with their lean bodies and long hair knew very well which mushrooms were psychedelic and what their effects were.

One mycologist, a woman in her forties, told me that mycologists never eat raw mushrooms, not even the button or portobello mushrooms that are farmed and sold in stores, and she recounted a story that had been in the news several years ago when a chef at a local four star hotel had served raw shaved morel mushrooms in a salad at a banquet and had poisoned several dozen people. A raw morel is poisonous.

Around five we all assembled on the deck of a building that was closed. People handed in their specimens and there was more show and tell about what had been found, about twenty different kinds of mushrooms in all.

There was a break for dinner and people met and ate at a restaurant on the Fraser River. I sat with Diane, Shaun, my Israeli friend, and an astronomer. As I began to sort out mycologists and astronomers, I made some general observations. The mycologists are lean and the astronomers are on the hefty side. Mycologists have long hair and beards; astronomers are clean-cut.

After dinner we went in our individual cars to another part of the forest. Perhaps it was another forest altogether. Maple Ridge on a late spring day, even a sunny one, has that rainforest Gothic feel of gloom and unease that was picked up so well by David Lynch in *Twin Peaks*. Maple Ridge, on the north bank of the Fraser River, is at the foot of a small mountain range—hence the location of the observatory—and not nearly as suitable for farming as the Valley across the river. There are parts of farms here and there; everywhere there is mold and rot. People certainly don't keep their property the way they do in Holland or West Germany: things need mowing, trimming, and painting.

We convened around 8:00 pm in a meadow below the observatory and the astronomers began to set up their telescopes. These were large and, I imagine, fairly expensive instruments. Our attention had been given to the ground for hours; now our heads looked up. As I said, it was really fortuitous that the weather was good.

The day had been chosen for the sake of the stargazers for they require a moonless night. As one of them said to me, "considering our passion we are not in a good part of the world." There are 12 or 13 new moons a year and chances are many of them will occur above an overcast sky. So this May day was special and treasured. Before anyone looked through a telescope we looked at the darkening blue sky and observed one by one the faint, barely-perceptible, specks brighten. I can't remember what was first, most likely Venus, which can be seen in a pale azure post-sunset sky before anything else.

It took hours for the sky to totally darken. There was an order to looking at things. First, the visible planets—Saturn's rings were the most mesmerizing. Then, a far off double star. Then, as midnight approached, people began aiming the scopes at galaxies. A small bus took people up to the observatory in shifts. It got cold quickly after the sun went down and most of us seemed a bit underdressed, especially as our activity—waiting, adjusting, peering—was really so idle. I

spoke to several astronomers about their telescopes and what they liked to look at. Were they all men? I can't recall. The mycologists, however, were definitely gender mixed. It was very dark, as flashlights, etc., would interfere with the viewing.

Yes, this attention to the sky induces wonder but, unlike looking at the ground with its infinite variety (every mushroom is an individual), there can't be any surprises. The most interesting thing to look at was actually the International Space Station which flew overhead twice while I was there (every 91 minutes, according to the NASA web-site). It is stimulating to imagine the universe, its numbers and vastness exceeding the boundaries of the imagination, however I couldn't help thinking of the line Ellen Burstyn delivers to David Warner in Alain Resnais' fabulous movie, *Providence*. After Warner's character, Kevin, goes on some jag about the wonder of it all, she says "Oh, Kevin, I'm not over-awed by the universe," with the impatience and boredom Burstyn is so good at.

Around midnight, I got too cold and left with my friend. The astronomers intended to stay all night.

I don't know how much interaction went on between the two groups. Both seemed really happy to share their knowledge and enthusiasm. Diane is a mycologist and this was her point of entry for conversations. Because she does belong to one of the groups of amateur scientists, most found it easiest to leave her identity and role there. On the other hand, I was always asked whether I was a mycologist or an astronomer—never the third group, the artist and her party. Everyone I spoke with paused, if only for a moment, to negotiate who I was and what it meant to be in a work of art.

As I have implied, the two groups seem quite different types. The astronomer I spoke with most is a banker and, as I imagine the telescopes cost as much as a nice car, these are comfortable men. The mycologists looked like they had been part of the counterculture. It was interesting to reflect on what types are drawn to the sky and what types to the forest floor. Hannah Arendt opens her great book, *The Human Condition*, with a meditation on the strangeness of living in an age (the Space Age, we used to call it) when, rather than seen as wasteful pathology, the attempt to leave the planet is the highest and noblest calling of nations.

* * *

I was interested to see how this work would be represented in a gallery, which happened a few months later. This was my student's concern in the first place: to really look at how these 'relational' works are documented and presented; when and how the document becomes the work; and the work's relation to the original event. Of course, it's impossible to really test these relationships. In the gallery, a text explained the event set-up as well as when and where it had taken place. Still images, photographs taken at the event, were projected on a wall. If you were at the event, as I was, you can't judge what the piece conveyed to someone who wasn't.

But I would say the piece in the gallery was a work of art and that it is not so hard to imagine looking for mushrooms or looking for stars even if you weren't there, and, finally, that the work of art is really to imagine this figure who spends an afternoon looking down and an evening looking up.

Again, I'm sorry I didn't manage to write the essay.

Best,
Scott

The Chinatown Foray

I invited the Mycological Society of Toronto (an amateur mushroom hunting club) to go on a mycological foray in the Chinese supermarkets and medicinal shops of Markham, Ontario.

We collected specimens in the suburban marketplace and studied them with our magnifying glasses and field guides. We noted characteristic features and debated Latin species names in the same manner that we would study Ontario fungi in the forest or field.

Performed in Markham in 2008, and with the New York Mycological Society in New York City, 2010.

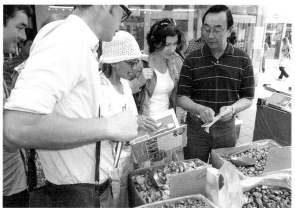

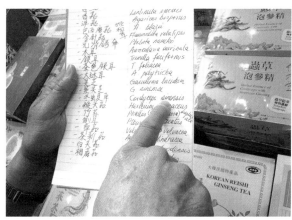

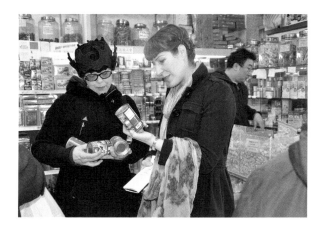

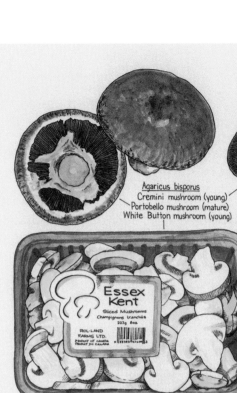

Tremella fuciformis
Silver Ear

Agaricus bisporus
Cremini mushroom (young)
Portobello mushroom (mature)
White Button mushroom (young)

Sparassis herbstii
Cauliflower mushroom

Flammulina velutipes
Velvet Foot mushroom (young)

Volvariella volvacea
Straw mushroom

Pleurotus eryngii
King Oyster mushroom

Auricularia auricula
Wood Ear

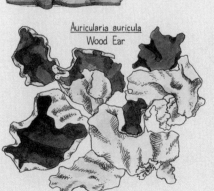

Cordyceps sinensis
parasitic mushroom and worm host

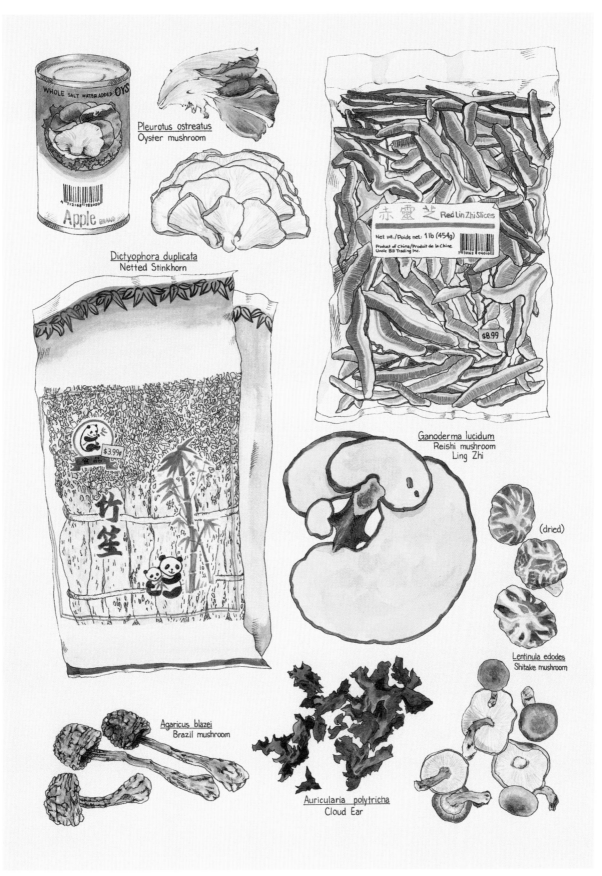

WHOLE SALT WATER ADDED OYS

Apple BRAND

Pleurotus ostreatus
Oyster mushroom

赤靈芝 Red Lin Zhi Slices
Net wt./Poids net: 1 lb (454g)
Product of China/Produit de la Chine
Uncle Bill Trading Inc.

$8.99

Dictyophora duplicata
Netted Stinkhorn

Ganoderma lucidum
Reishi mushroom
Ling Zhi

$3.99¢

食品

竹笙

(dried)

Lentinula edodes
Shitake mushroom

Agaricus blazei
Brazil mushroom

Auricularia polytricha
Cloud Ear

Natural History

From the postcard multiple, *Natural History*,
New York City, 2009.

Next Page

You Go To My Head

A woman attempts to sing a song with her husband's breath and vice versa. Each singer draws air from the other's lungs (as in mouth-to-mouth resuscitation) in order to perform the 1938 song, "You Go To My Head," by J. Fred Coots and Haven Gillespie.

While the song describes the experience of love to be like drunkenness, the performers increasingly struggle to remember the words, the camera, or to produce a musical sound at all. They are simultaneously supported and depleted by the other's breath. She looks exhausted and upset, and he looks drunk and at risk of blacking out. The tension builds in each scene as the challenges of the feat affect both of the performers' bodies and amplifies their gestures of attentiveness and dependence.

Performers: **Eric and Loretta** Technical Production: **Nathan Saliwonchyk**

Commissioned by the National Museum of Fine Arts of Quebec. Shot in Burlington, Ontario, at the home of the performers. Edited in Toronto, 2009.

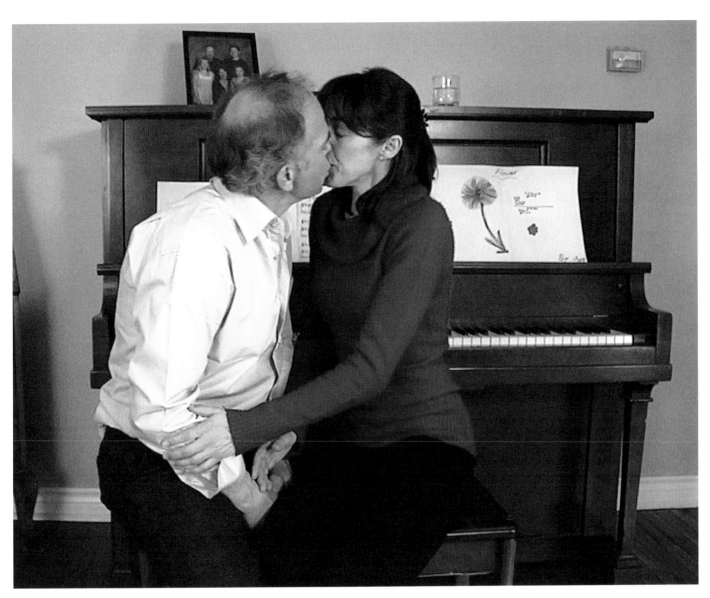

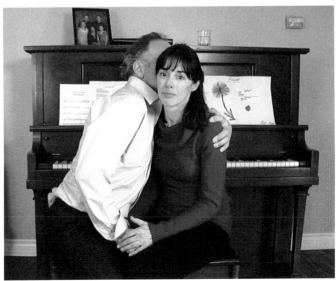

Snakebus

I hired a reptile educator to deliver an adult-oriented demonstration on a moving bus. A crocodile, turtle, skink, and several snakes were available to touch and hold while passengers were in the enclosed space for the duration of the one-hour trip.

As part of an ongoing series of acts, I have been inviting substitute educators and performers to convey ideas and experiences at play in my work.

Reptile Educator: **Blair Watson**

Commissioned by the Art Gallery of York University for *The Performance Bus* **in Toronto, 2009.**

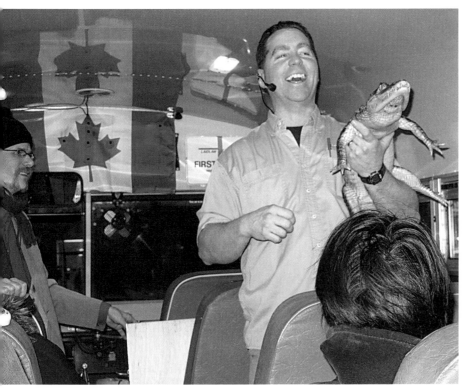

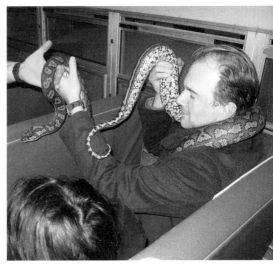

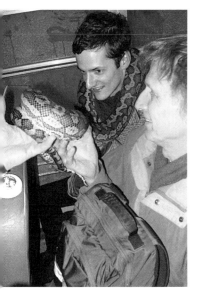

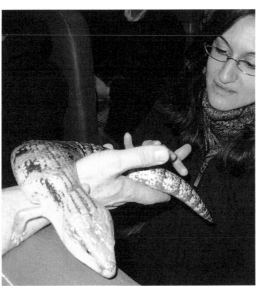

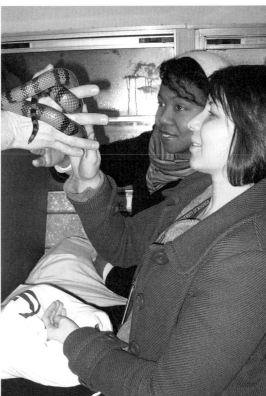

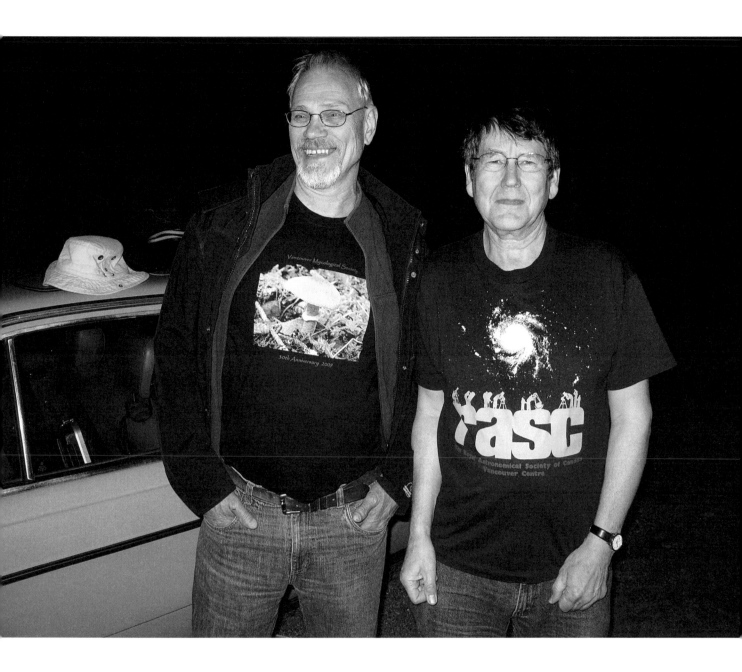

Terrestrial/Celestial

I coordinated an exchange of terrestrial knowledge for celestial knowledge between amateur mycologists and astronomers.

First, the mushroomers hosted the astronomers on a daytime foray to collect and identify fungus species. In the evening, the astronomers hosted the mushroomers to look through telescopes at stars, planets, and satellites.

Performed for Access Gallery in Maple Ridge, British Columbia, with the participation of the Vancouver Mycological Society and the Royal Astronomical Society of Canada (Vancouver Centre), 2010.

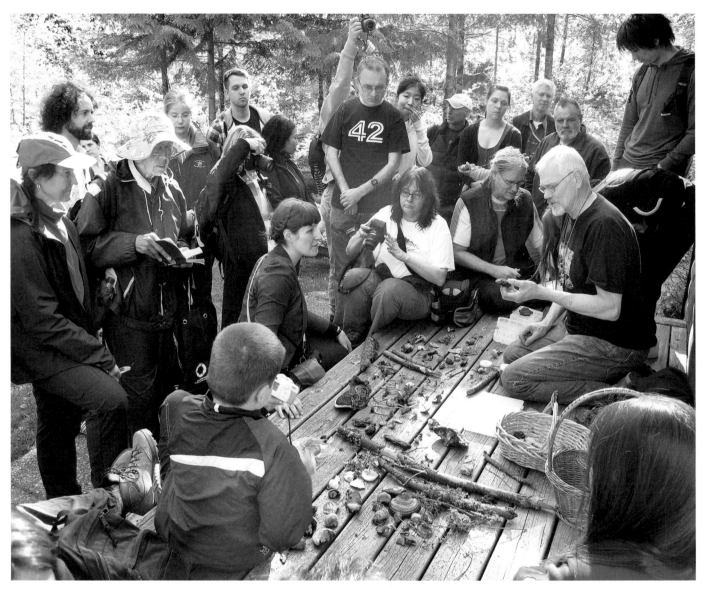

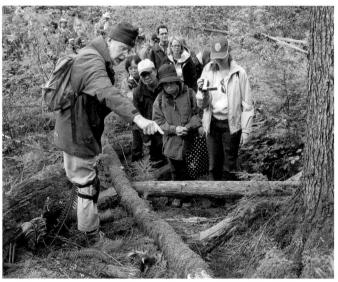

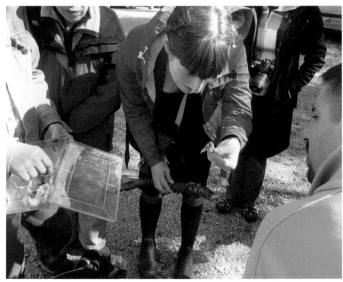

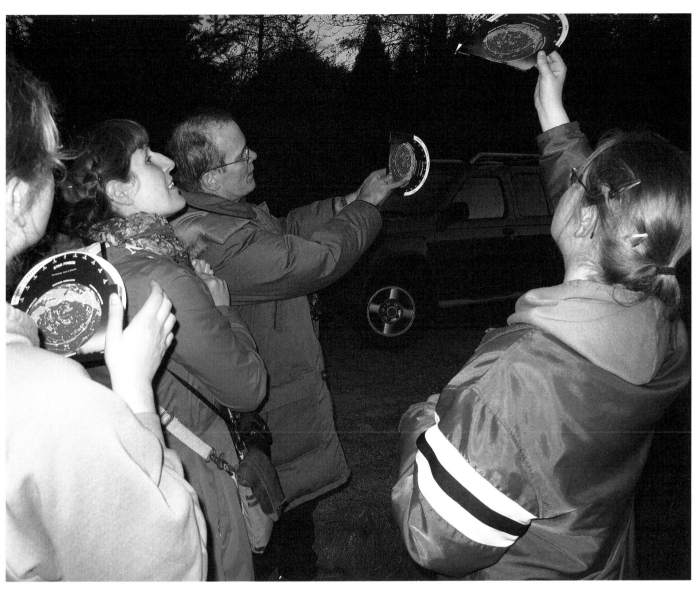

Falling Piece

I hired six contemporary dancers to infiltrate a benefit gala at the museum. The dancers, dressed as elegant party guests, staged a range of "accidental" falls—some discreet and some theatrical.

The performers were meant to look as if they had lost their balance, and to give the impression that the museum was somehow dangerously slippery and unstable. Thousands of attendees witnessed more than one hundred staged falls.

Dancers (Toronto): **Cara Spooner, Michael Caldwell, Evan Webber, Alicia Grant, Keon Mohajeri, Matthew Romantini**

Dancers (Vancouver): **Cara Spooner, Carolyn Chan, Alex Thompson, Noah Drew, Paul Ternes**

Commissioned by the Art Gallery of Ontario in Toronto, and restaged at the Vancouver Art Gallery, 2010.

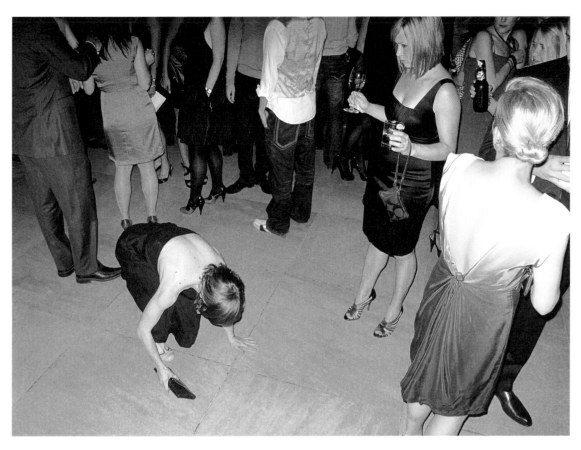

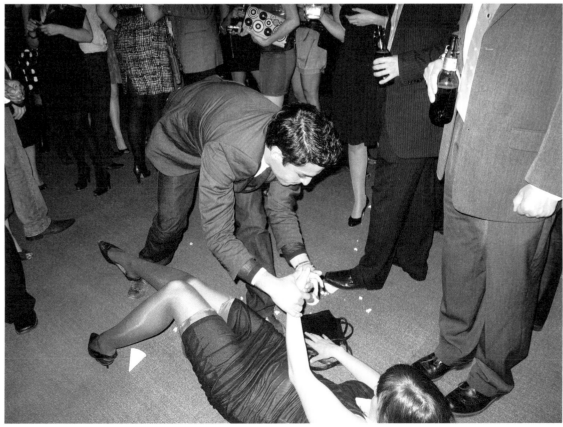

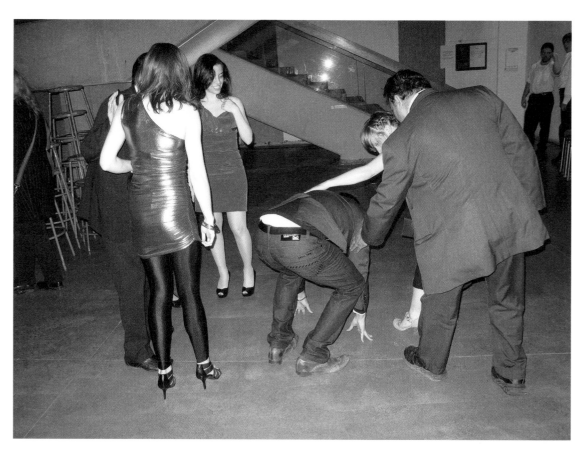

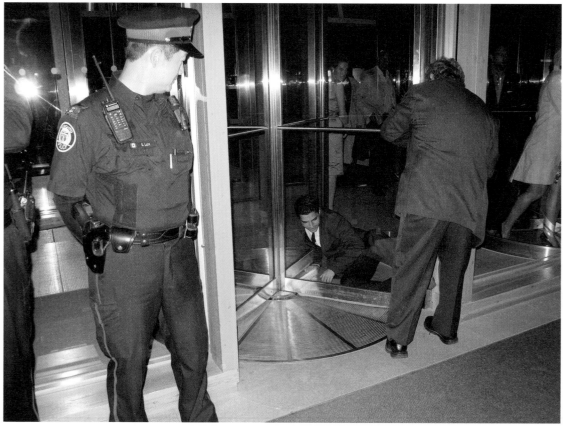

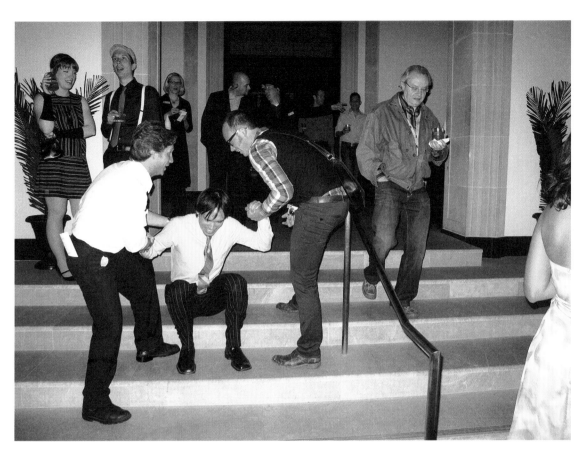

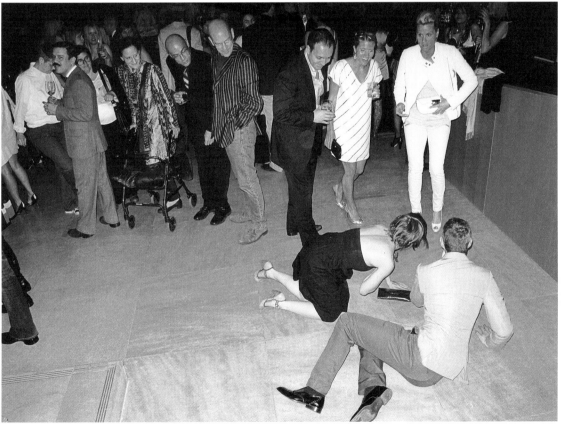

Walking Studio

Walking Studio is an 11 x 18 foot building that functions as a mobile field-study space that can be installed in urban or wilderness sites. Assembled or dismantled in a few days, one part of the structure consists of a screened-in study room with shelves and worktable, and the other part is a cylindrical space that functions as both a small sauna and a secure sleeping area.

The artist-in-residence can gather local materials and work on site-responsive research in the study room. The worktable allows for examining objects and natural specimens, reading, drawing, and hosting guests for tea and discussion.

The sauna can be fired by wood from the surrounding site, and can use local stones for radiating heat. The private space allows for recovering from fieldwork, and for further reflection.

The studio is a place for research, teaching, and learning. It serves and gives material form to artistic practices that are site-responsive, peripatetic, and relational. The building allows for a processing of local materials, ideas, and relationships and, like an industrial machine, it releases the by-products of this work as steam and smoke back into the surrounding environment.

The first residents in the studio were artists Janis Demkiw, Emily Hogg, and Olia Mishchenko of Terrarea while the studio was installed in Redickville, Ontario, on the rural property of Don Miller.

The structure was designed in consultation with Adrian Blackwell and Jane Hutton for the Art Gallery of York University in Toronto, 2011.

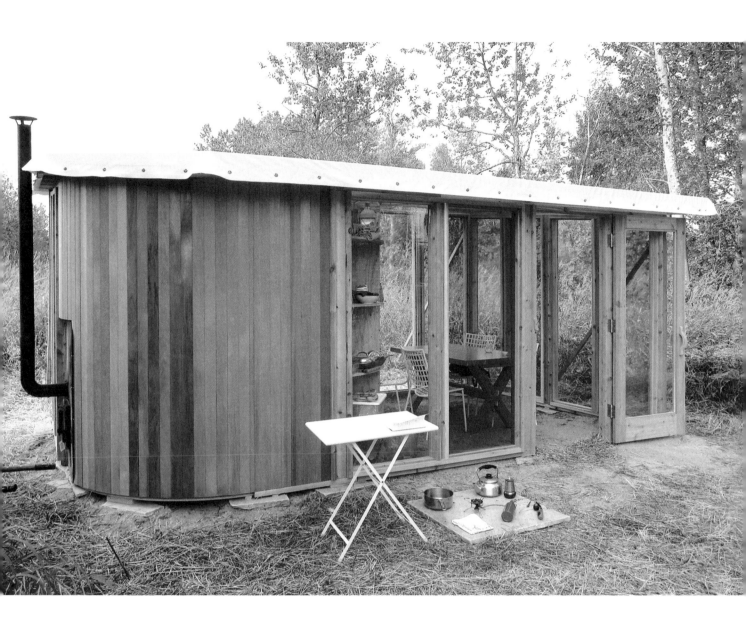

Walking into and alongside Diane Borsato's *Walking Studio*

Emelie Chhangur

Following Footsteps

> *There are two modes of criticism. One which…crushes to earth without mercy all*
> *the humble buds of Phantasy, all the plants that, though green and fruitful, are also*
> *a prey to insects or have suffered by drouth. It weeds well the garden, and cannot*
> *believe the weed in its native soil may be a pretty, graceful plant. There is another*
> *mode which enters into the natural history of every thing that breathes and lives,*
> *which believes no impulse to be entirely in vain, which scrutinizes circumstances,*
> *motive and object before it condemns, and believes there is a beauty in natural form,*
> *if its law and purpose be understood.*
>
> — Margaret Fuller "Poets of the People," *Art, Literature, and the Drama* (1858)

Writing a text on Diane Borsato's work is a tall order task. Maybe it's not as risky as the tasks she's given herself over the years: to touch a thousand strangers in a month in the streets of Montréal (*Touching 1000 People*, 2001/2003) or to steal flowers from private gardens in Toronto in order to make bouquets to exhibit as sculptures in galleries (*Bouquet*, 2006–12). Certainly not as visceral as when she put dusty old museum artifacts into her mouth, "intimately experiencing the objects, with…tongue, lips, and sense of smell" (*Artifacts in my Mouth*, 2003).[1] But it definitely *should* be.

The task's difficulty is not so much deciding what to write *about*—though admittedly this is not a simple job either, complexity begets complexity—but rather *how* to write about Borsato's work that's most challenging. The task is to find a strategy that addresses the issues at stake in her particular approach to art making so that one might get to the heart—or the 'bones,' as she might say—of her practice. If her artwork proposes alternative paths of inquiry through embodied, participatory—and sometimes socially engaged—projects, what should our (my) path be here?

There are other difficulties. One is rarely able to experience in person a Borsato performance since they are sometimes hardly noticeable gestures (for example, *A Series of Minor Incidents*, 2006–07); or they are one-off events designed primarily for individuals outside the art frame (i.e., mycologists or astronomers, for example, in *Terrestrial/Celestial*, 2010); or they are performed alone by the artist (for example, *Sleeping with Cake*, 1999). But the main difficulty in learning about these works is that they themselves are about learning. How do you put learning about learning on display? A difficult task indeed!

Thus, what is at stake in learning about this artist's work is the *way* in which we learn. At the heart of Borsato's practice is a pedagogical question.[2] How, therefore, could I learn about a practice that itself proposes alterative ways of learning about the world and our relation to it? I figured my first move forward was to step away from the gallery and get out into the real world.

So how do we *learn how to learn* about Diane Borsato's work?[3] In order to leave footprints one must first follow footsteps. One has to step *into*, not back from, her work. When the artist learns through other fields of research, such as in a naturalist foray (*The Chinatown Foray*, 2008/2010), she learns something about the nature of her own practice. She sees through the eyes of amateur practitioners, whether astronomers or mycologists, so that she may look at the subject of her own work from a different position. As the artist learned Italian while being tutored about physics or studying beekeeping (*Italian Lessons*, 2007–11), I might come to her work through learning something else altogether.[4]

We learn about Diane Borsato's work from learning *through* it. Mimicking her procedures, I first need to *experience* her work through alternative forms of engagement so that I might learn how to understand it differently, or, at the very least, learn how to see it from a different perspective.

In order to follow in Diane's footsteps a little fieldwork must be done, some risks taken, and the boundaries of art discourse, frankly, ignored so that new possibilities of learning can be tested, and engaged methodologies of interpretation proposed. Borsato's 'art work,' in the form of its photographic documentation, is, simply put, an elegant mediation on issues at stake in her own performance practice: social behaviour, embodied learning, relational experiences, and unconventional exchanges of knowledge. Likewise, learning through Diane's practice means having the opportunity to simultaneously think about what's at stake in my own curatorial practice vis-à-vis relational work.

* * *

Changing positions: stepping outside of the box and into the frame(work)

If our first step forward is to follow Diane's lead, the path should take us on an alternative journey that defies, according to the artist, "ways of knowing that aren't solely based on reading texts or seeing." At very least, our learning is in the *doing*: we have to get up and get out in order to start our journey. We learn by walking.[5] A word to the wise: depending on which path you take into Diane's work, you might get stung along the way!

Following her own multi-sensorial ways of knowing, we might ask: what does a Diane Borsato work *feel* like? An unusual question, I suppose, given that traditionally we are taught precisely *not* to physically touch, breathe on, rub up, or get too close to a work of art. Obeying the conventional rules of art would be counter-productive to the task at hand, however. Getting stung is par for the course. In the case of Diane's work, an exchange of touching—or, better yet, a *touching exchange*—is completely in order. To learn through Diane Borsato's work means finding a tactile, feet-first engagement with a subject, walking full stride forward past limitations artificially imposed on us by traditional learning. In other words, taking the path less travelled into unknown territory.

Luckily for me, this path had already been cleared. It was located in Redickville, Ontario on the periphery of Don Miller's farm where Diane erected her most recent work, *Walking*

Studio (2011). This studio is a small building made of cedar, with its walls of transparent plastic sheeting and mesh screen and its roof of a translucent white tarp. *Walking Studio* was designed as a framework for a specific kind of learning—Diane Borsato-style learning, which, as we know, is based on other forms of learning: paths taken by her over the years through other disciplines such as mycology, astronomy, apiculture, and naturalists' forays, all of which could be fulfilled here again. As a "mobile field study lab," the *Walking Studio* highlights the act of engaged learning, research processes, collection, and reflection.[6] It contains a small study centre with a worktable, shelves, and cork board as well as a fully functional Finnish-style sauna, which doubles as—according to the artist—"a secure sleeping space," though she has never actually slept there. (This wasn't going to deter me, however.)

From August 26–30, 2011, I became a 'resident' of the *Walking Studio* so that I could engage in alternative ways of learning about Diane's work while literally being a part of it. By actually living in the work, I hoped to simultaneously develop a parallel approach to curating/writing that would *embody* the operative strategies underlining her work. I set out to learn how to learn about engaged art practices by creating one of my own.

Despite the seriousness with which I was approaching this work, I thought this little experiment might also be fun, regardless of the anxiety I felt about sleeping alone in the middle of nowhere with none of my urban amenities. Apparently fieldwork doesn't require a proper washroom. I would have to learn how to cope. If you talk the talk you have to walk the walk. I suppose this was the first step in.

* * *

A Rogue Investigation: setting out

From: Emelie Chhangur
Subject: emelie + the walking studio
Date: August 7, 2011 5:28:48 PM EDT
To: swintak, don miller
Cc: Diane Borsato
Reply-To: Emelie Chhangur

Hi Swintak and Don (and Diane),

I am writing a text for Diane's monograph that will accompany her exhibition at AGYU. Today I had a thought about how I would like to approach this. I know that Diane is away at the moment and I would like her to weigh in on this too, but I wanted to write to you sooner rather than later in case the *Walking Studio* is being booked up.

I would like to come for about five days to be a resident. I am going to write my text while I am there *(in a note book, as a diary) thereby embodying Diane's work, at the same time creating a piece of writing that is in direct response to the *Walking Studio* (thus fulfilling

its intention as a work in situ at the farm). It would allow me to put myself in a situation where I won't know the outcome, and learn something through an embodied experience of touching, tasting, exploring, foraging, etc. Frankly, it scares the shit out of me, but I feel that this experience will bring me closer to understanding Diane's work by embodying it myself as an action *inside* her work. This will also create a different relationship for me to the *Walking Studio*, which will be installed at the AGYU in the spring of 2012 (where I anticipate it taking on an entirely different meaning). From the point of view of being the curator of the show, I think this is an interesting approach to have to a work of art. It is also a matter of being part of the work, to test its possibilities, and to using my time there to explore its original site and create a field record of the *Walking Studio*'s relationship to Don's farm for Diane on a different sort of scale (and in a way that is not traditionally expected from a curator).

I know that you mentioned an interest in having a curator or writer come. I am wondering if that can be me? What do you think? Could you let me know if there are any available dates left?

Thanks!
Emelie

Emelie Chhangur
Assistant Director/Curator
Art Gallery of York University (AGYU)

* * *

A Personal Foray: notes from the field

August 26, 2011

9:45 am I'm frantically trying to finish packing before Diane arrives to take me to the *Walking Studio*. I start to move my 'supplies' downstairs. I have a lot of stuff—trying to be prepared for something I have no idea how to prepare for and trying to anticipate what I will need, even though I don't know what to expect…

10:15 am Diane pulls up to my place, we greet each other and she helps me load my supplies into her car. I think she is a little shocked by the amount of stuff I have: bedding, warm clothes, light clothes, bathing suit, toilet paper, water (lots of water), computer, portable generator, field recorder, notebooks, pens, and a bag of dehydrated food—nuts, seeds, etc. I think she's also perplexed as to why I am subjecting myself to this process. To be honest, her expression makes me even more nervous. I am, after all, supposed to be learning from her!

10:30 am Our journey from Toronto to Redickville begins. As we drive off I feel a bit anxious: why *am* I doing this? Have I forgotten something? Will I even be able to write?

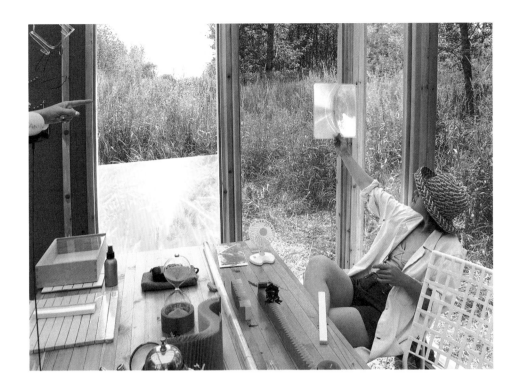

How will I deal with sleeping in the deep, dark, rural landscape? The uncertainty is a little nerve-racking to say the least. I presume this is how Diane must feel when she embarks on one of her eccentric experiments with other disciplines or enters into situations that are outside her area of expertise. Right now I have butterflies in my stomach. Later, I will have spiders in my sleeping bag. Diane is talking about her recent experiences on the east coast of Canada and we miss our cut off to Highway 10 and have to double back. The delay doesn't really bother me. I am distracted by the thought of those spiders…

1 pm We finally arrive at Don Miller's farm where the *Walking Studio* has been installed since early summer. We pull up to the main farmhouse: the 'Frankenbarn.' Here is a tangible example of alternative thinking, I thought to myself. The Frankenbarn is the product of twenty years of work—still ongoing—and a larger-than-life piece of intuitive architecture if ever there was one. We are greeted by artists Janice Demkiw and Olia Mishchenko, who are here preparing for the third iteration of *Don Blanche*, a weeklong residency-style project for artists and the surrounding rural community, conceived and organized by artists Swintak and Don Miller. Coincidentally, *Don Blanche* will be taking place here while I am 'in residence' at the *Walking Studio*.

After a tour of the Frankenbarn, Diane and I head down a dirt path toward the *Walking Studio*.

The interior is overgrown with various plants and weeds. Since there is no floor to the *Walking Studio* whatever grows around it grows in it. I am immediately struck by the permeability of interior and exterior space. Diane seems pleased to see the *Walking Studio*

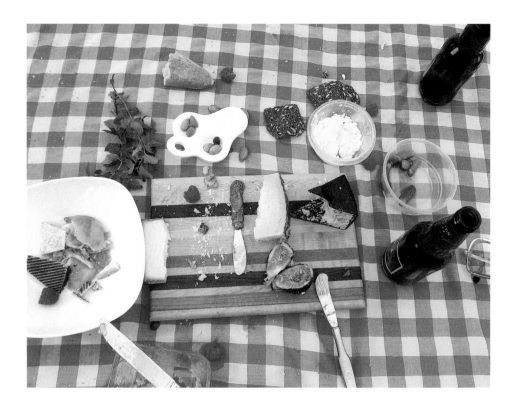

still intact, despite the recent thunderstorms and strong winds that swept the area in the days preceding my visit. Permeability. The weather. The reality of the situation is starting to set in…. Getting close and personal with Diane's work is no longer an abstract concept….

I start bringing in my supplies as Diane organizes the supplies already at the *Walking Studio*: dishes, soap, a cooler for well water, a small camping stove, tea, kettle, tea-pot, specimen jars, books,[7] and a custom-made half-moon shaped mattress: my bed. Diane begins to weed the floor of the studio. As she grabs one of the more menacing looking weeds it stings her. Bradford Angier's *Field Guide to Edible Plants*, one of the books included in the studio's 'library,' confirms our suspicion: stinging nettle.

Recovering from the sting of the nettle, Diane adverts to the picnic she's packed for us. As I examine some little black toads that will be my housemates for the next five days, she pulls out a beautiful wicker basket and sets it on the table. Pulling out the requisite red and white checkered tablecloth, she lays it out on the custom designed wooden table followed by an assortment of wonderful artisanal cheeses, a rustic baguette, raspberries, figs, specialty crackers, almonds, cranberries, and—the *pièce de résistance*—a honeycomb and honey made by her own backyard bees. Olia and Janice join us for the picnic. We talk about the preparations for *Don Blanche* and about the honey and the bees….

After the picnic, Diane quickly and efficiently clears the table, carefully packing everything back into that little wicker basket from which it came. Table cleared, she proclaims, "see, now it looks like a work table!" Leisure time suddenly shifts to work time. We had been

heating some water on a little portable camping stove for about an hour and it was finally ready. We make some of the coca tea I had brought, even though there was a 'curated' selection of tea already on-site—smoky tea for drinking in the sauna, for example. We drink the tea from little glass cups found on one of the shelves of the *Walking Studio* until Diane has to leave. As she packs to leave, I unpack to stay. I start to re-organize the space according to my needs. She hugs and kisses me goodbye and suddenly she's gone. I hear her car driving down the gravel road as I take a pee in the woods….

6 pm I just turned on my phone to check the time. I have no real concept of time here and I suspect I will become less and less concerned. It already feels like a lifetime since Diane left. I'm sitting here at the worktable with my computer and portable generator, wondering what to do next. There are no words to describe the silence, the heat, and the gentle breeze in the trees surrounding me in the *Walking Studio*. From time to time I hear a fly or a bee buzzing around my head. I'm going to tour the farm and its amenities—a makeshift shower, the frog pond, the well, etc.—but first I will change the batteries in the flashlights and set out the candles. I only have a few precious hours before dark and I need to be prepared. I think I might need to go to the washroom and not the easy kind. Forget art. The main learning curve here is dealing with the basics!

I think it's late. It could very well be the next day, but I'm not sure. After spending some time writing on the computer—until my portable generator ran out—I went up to Frankenbarn to 'recharge.' I think that was about 8 pm because it was starting to get dark…. Not long after, Swintak, Emily Hogg, 'Dee Dee' the chef, and two other artists, Sebastian Koever and Matias Rozenberg, arrived. They talked about the past projects of *Don Blanche* and enthusiastically wondered about the ones that might transpire over the next week, including my own here at the *Walking Studio*….

One of the most interesting issues that came up was a debate about funding. *Don Blanche* had received two grants this year. The question of incorporation had come up (establishing a board of directors and thus a sense of 'fiscal responsibility,' to use arts council lingo). This, coupled with the burden of responsibility, as Swintak said, of spending "tax dollar money," they questioned how they could negotiate a position within the 'art system' while still functioning 'off the grid' (and therefore not be accountable to outside forces) so that they could continue benefitting this place, the artists, and the surrounding rural community. It was an ethical issue, too. They needed to stay true to their ethos, which was communal, transparent, and inclusive, and not create restrictions by establishing unnecessary organizational infrastructures that would, in turn, contradict everything they were trying to achieve: freedom. Being off the grid means following the practices of the farm, which functions in an entirely self-sufficient manner. Their work has to function in a similar way or else it would contradict the very foundation on which *Don Blanche* was based. I could relate—in a sense I am having a parallel experience with Diane's text…. If you continue going down the same old path, you will never arrive at a different place…

Swintak brought out a copy of the grant acceptance letter from the Ontario Arts Council and read it to us. She pinned it to the communal corkboard, which sits next to the communal chalkboard (where residents list their projects for others to collaborate on), and discussion

was tabled to a later time when more people were to arrive for *Don Blanche*. Issues would be transparent and decisions on how to move forward would be done collectively. This was the art of participation. I decided to pin a copy of my text-in-process on the corkboard at the *Walking Studio*.

At a certain point in the evening I invited people back to the *Walking Studio*. It was interesting to hear their comments, which were primarily about the structure itself: its formal properties and use of materials. It dawned on me that in order to move beyond aesthetic observation into active participation I would have to bring people *into* the *Walking Studio* and engage others as a part of my own field research. I'm starting to think of Diane's practice as a kind of 'functional conceptualism.' The *Walking Studio* is both instruction for a way of working as well as a usable space. It is a functional space for non-artists and artists alike. It is at once an alternative to the fixed artist studio and the naturalist field lab. Both the conceptual framework *and* the current inhabitant's work are the content of the *Walking Studio*. Both are site-specific, relational, and peripatetic. As a sculptural object, the work is unresolved: in order to *understand* it, we must activate it. The *Walking Studio* is a place *for* contemplating and not something *to* contemplate. It is not an object. It is practice put into form.

At the moment, I am laying in the sauna room, under the covers on my little half-moon mattress, *feeling* the *Walking Studio*: it's cold; I have to pee; there are bugs all around me. In my notebook, I'm recording the earlier observations I made about people's reactions to the work—both what was said and how they navigated the structure (no one went in without an invitation, by the way). All of this is a way to see how the work *works*. I am going into the woods now. It's been a really interesting and challenging night. Learning through Diane's work is…well…a lot of work.

August 27, 2011

10 am I've just gotten up. It's taken me a few minutes to register where I am. It feels odd to be in a perfectly round room. My hair smells like cedar…. I've decided that I am going to spend today writing at the Frankenbarn. I am becoming more and more curious to think of myself as being framed by the *Walking Studio* and the *Walking Studio* as being framed by *Don Blanche*. *Don Blanche* will be another thing I learn while learning about Diane Borsato's work because the *Walking Studio* is located here. What grows around it grows in it…the *Walking Studio* requires a different kind of investment than other art works I have curated or written about. This is not going to be a matter of simply sitting down at a computer and working through ideas in writing. Ideas will be worked out through participation, both inside and outside the *Walking Studio*. It will also involve other people. Being on Don Miller's farm and participating in *Don Blanche* is the perfect context for me explore ideas contained, or materialized, in the *Walking Studio* as much as the *Walking Studio* is a place for me to explore *Don Blanche*: a form of unconventional curatorial research in collaboration with artists. It is important that I am here roughing it alongside them. It is about building trust in a non-hierarchal way. By working at the *Walking Studio*, I am getting a deeper appreciation for Diane's other works, which have

depended on the expertise of others (mycologists, astronomers, educators, and beekeepers). These past works are not so much defined in terms of material objects but by ephemeral processes of interaction between people and places. It is a dynamic learning relation. Don't get me wrong: Diane's work is not about collaboration, though some of her work opens up the possibilities for others to work together.

6 pm Here I am sitting at the long communal dinner table, writing notes, making drawings, and watching people come and go. Swintak is arranging flowers around me. Dee Dee is cleaning the wood-burning stove, getting ready to prepare the meal for tonight. I still have to put my tasks up on the chalkboard as I integrate the *Walking Studio* and my own research project into the *Don Blanche* experience. I've decided that I will transcribe this diary (my so-called field notebook) and include it as part of my text. I think it is important to provide a transparent window into my process as a strategy to intentionally subvert conventions of curatorial writing. Following Diane's path means complicating the ways through which we engage in learning about a subject as much as it is about how the subject engages in learning. I am not afraid to reveal something about myself in this text. It is about merging my work with hers. And of taking risks and following paths that take us outside our own comfort zone. Getting stung is par for the course!

8 pm …Since Diane has not stayed at the *Walking Studio*, I figure she must be more interested in how others engage with the space, learning through the residents: learning by learning through other people's work there. In a sense, my text will be as much for Diane's eccentric wonderings as it is a record of my own. It will be a *part of the Walking Studio*. A by-product. An experiential document… there is an amazing fruit fly colony developing on the window adjacent to me. I have to go and inspect it…

Later I've just slipped away from the group to come back to my lab. I spent most of tonight engaging people in ideas about Diane's work. People seem genuinely interested in how I've decided to approach learning about this work, which is comforting because they are all artists. They too are here to engage in alternative paths of learning and doing, living in a dynamic equilibrium with their immediate context and making this the basis of their work. I feel more comfortable here tonight and I actually looked forward to retiring back into the world of the *Walking Studio*, which I am finding more and more a place for thinking about what is going on around me at the farm. Here at *Don Blanche*, as with Diane's work, strategies of engagement (with people and location) are an important part of the artwork's aesthetic language. Relationships might in fact be the artwork. Authenticity can also be an aesthetic strategy.

August 28, 2011

4 pm I spent the better part of today mapping the *Walking Studio*'s position in relation to all the other elements located on the farm as an alternative way of situating it in its present context. The *Walking Studio* is exactly 35 steps from the communal sauna; 40 steps from the communal hot tub; 44 steps from the frog pond and swimming hole; 47 steps from the cabin; 75 steps from the end of the path where the metal posts are; 105 steps

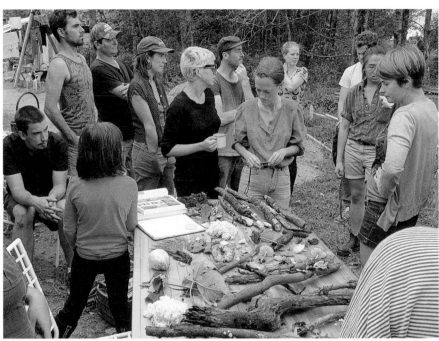
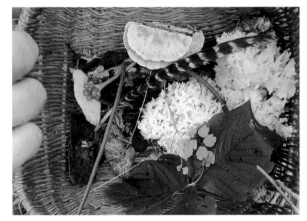

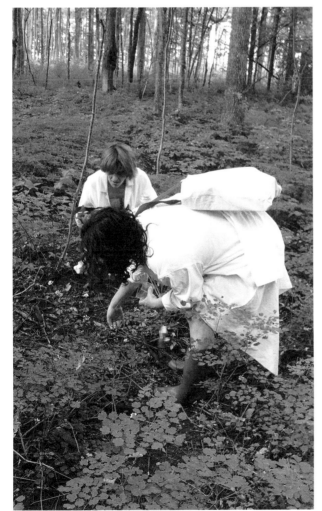
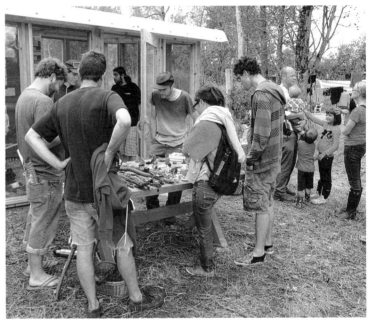

from the outhouse; 150 steps from the pyramid; 185 steps from the floating cottage; 200 steps from the Frankenbarn; and 256 steps to the outdoor communal dining table. At the end of my experiment, I headed back to the *Walking Studio* (taking the long, 300 step route) to make a cup of soup. I am waiting for the water to boil and thinking about intimacy. I'm going to miss being here.

August 29, 2011

1:30 am Tonight was very productive, though I didn't actually do any writing. Instead I put the ideas I've had about Diane's work into practice: authenticity, intimacy, building trust, etc.… I ate with everyone at the Frankenbarn—we had chicken and sausages, succotash, tomatoes and basil, and *lots of wine*. I had a number of one-on-one conversations about Diane's work in general and the *Walking Studio* in particular. I talked for some time with Sandy Plotnikoff. We talked about agency and artistic intention. For instance, even if I used the *Walking Studio* for a different purpose than the artist envisioned (indeed I doubt Diane ever thought it would be used to learn about *her*) my approach to my work would still fulfill her work's proposed methodologies. This is because the methodologies, like the ever-shifting content, are both the subject and strategy of the work. They contain and are contained in its very structure. My bringing people into and activating the space (through discussions, actions, making tea on the portable stove, pinning things to the corkboard) has become a way to literally bring people into the work's discourse and conceptual framework. Essentially, I have to bring the *Walking Studio*'s 'context' inside it, just as I myself have to leave it in order to carry out the kind of site-responsive work its structure proposes. Thus, I've been creating a dynamic between the *Walking Studio* and its surrounding context (and vice versa). Here, in my field laboratory, my 'specimens' are also the people I've met: a form of social research that undermines conventional ideas of authorship, even over my own text. When people started to head to the communal hot tub, I brought people 40 'Chhangur steps' (as Sebastian affectionately called them) to my nearby wilderness hut to have tea and chat. I am simultaneously learning about the potentialities of the *Walking Studio* and about the artists who are participating in *Don Blanche*.

Now I am going to read Mikkel Aaland's *Sweat: The Illustrated History and Description of the Finnish Sauna, Russian Bania, Islamic Hamman, Japanese Mushi-Buro, Mexican Temescal, and American Indian & Eskimo Sweatlodge*, which I found in the *Walking Studio* library, to learn a bit more about sweating since sweating will be my project for tomorrow. I wonder what I would learn by reading the book versus what I will learn by doing the sauna: a.k.a. learning through sweating. Up until now, I have been learning through relating (people, objects, and ideas).

11 am I'm having a hard time getting out of bed this morning. It feels so comfortable and safe in the round room. I am lying here strategizing my day and imagining this space later hot and steamy. If the studio is for processing materials (including, in my case, also people) then the sauna is for processing ideas. I am going to fire up the sauna and spend the day on my own: engaging in solitary learning as opposed to collective learning. I'm

covered in insect bites. I have discovered something important about what is at stake in participatory or engaged forms of learning: commitment. It not as easy as one might think to really follow through on what this kind of practice proposes, despite the ease with which the art system has absorbed these practices into its discourses. Participation is a lot of work. Real work. The *Walking Studio* may be a quasi-conceptual project, but to activate it takes real labour, even if it is an alternative, creative form of labour. I can't believe this is what I am thinking about at 11 am before I have even had my first cup of coffee. Speaking of which, I better go and put the water on; it will take a while. Here, day-to-day living is also a commitment.

2 pm I've really been using the *Walking Studio* today. For the past two hours I have been scouring the forest for specific hard woods small enough to fit into the sauna stove but big enough to keep a good fire going. It has taken some time to heat up the sauna. A real commitment. I am back and forth, inside the sauna (sweating) and outside (freezing) to stoke the fire. As I sit in the sauna, the smoke escapes out of the chimney as if a tangible expression of the by-product of ideas coming in and going out of the structure. Drinking water and sweating it out. Everything smells like cedar. I can taste my sweat. I just heard some people outside the space. One of them literally just said, "wow, look at this, it's beautiful—what is it?" I have to go and talk to them.

Later The people whom I met earlier outside the *Walking Studio* were the artists who run *vsvsvs* in Toronto. I brought them into the *Walking Studio*, gave them a tour, and talked about Diane Borsato's work. (I think they were a little startled to see me come out of the work, dripping with sweat, naked save for a small towel…*whatever*…) In exchange, they told me about *vsvsvs*—part exhibition space, part residency for the production of other artists' work, and part home for this collective of artists. Another thing I have been learning, while learning through Diane's work, has been about artists' self-organized spaces. There is a younger generation of artists who are also following Diane Borsato's path and otherwise creating spaces like the *Walking Studio*, which are devised to promote experimental learning and new forms of artistic production.[8] There seems to be a new trend toward creating collectively driven art spaces—of working 'off the grid'—that are becoming far more experimental than their 30-year-old counterparts: the artist run centres. Here, part of the artwork is actually the process of opening up possibilities for others to participate in alternative ways of learning and doing, as Diane's does. Of finding forms of *welcoming* (I think back to Diane's picnic). What is also interesting about these initiatives (such as *DoubleDoubleLand*, *WhiteHouse*, etc., who are also here) is that they are self-sustaining: they are finding new models not only to show art but also to generate income, conceiving of the space as an artist project in its own right by creatively problem solving issues that are affecting artistic production and creative freedom—something particularly relevant right now, given the current political landscape of Canada… Ontario… Toronto…. Of course they are all drawn here to *Don Blanche* as the ultimate example of alternative living/working: of learning while doing, which is something I have learned a great deal about too, by living Diane Borsato's work.

10 pm I am getting ready for bed. I'm going to have an early night because tomorrow I will do studio visits with the other artists here. I will also offer them saunas. It's freezing

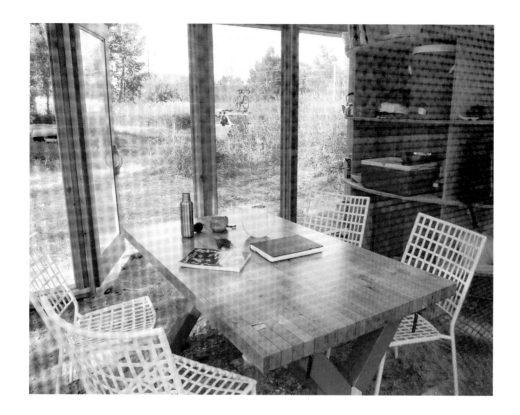

outside … but because I had the sauna on all day it is nice and warm in my little bedroom. It is truly lovely. Despite my initial hesitations, I *love* the *Walking Studio*. I laid out my pajamas earlier so that I could get into warm clothes before going to bed. Unbelievable. The smell of cedar radiates from the *Walking Studio*; I could smell it from about 10 Chhangur steps away.… I can't help but wonder, will this work once it is at the AGYU; will it reveal what really is at stake in the field? How will the *Walking Studio* propose a specific way of working that is site-responsive, peripatetic, and relational there? Will its presence incite new ways of working *in the gallery*? I hope so. In this sense, the work would mark a distinct shift in Diane's practice of gallery display—away from illustrating her past performances through detached photographic documentation and text toward providing embodied experiences for viewers. If we can find ways of participating in it, and not just looking at it, then we can let *experiences* inform new practices in exhibition-making and open up new opportunities for art's audiences by facilitating the opportunity for them to *participate* in the development of an artist's work.

August 30, 2011

5 pm Today I did studio visits and kept the sauna going for the visiting artists. I thought of this as an alternative way to exchange knowledge: I brought their practices into the *Walking Studio* and in exchange they took away with them the experience of an embodied way of understanding Diane's work. I also liked the kind of work I was doing for artists by way of the sauna. It seems like a metaphor for curating: I am a bridge linking the two

artists' works where the conversations go in both directions (in and out). My first visitor was Swintak. We talked for over an hour about *Don Blanche* and she said one thing in particular that is worth mentioning here. In creating a 'rural/contemporary' experience, they are developing relational, not oppositional, forms of participation in contemporary art: a form of unmediated engagement through the building of *authentic* relationships *through* contemporary art *and* farming. In this art 'event,' locals are not alienated. Farmers are the experts on the land, while the artists are experts in intervening in it. I thought of what the astronomers and mycologists get out of participating in Diane's work. What motivates them? How does Diane convince a reptile educator to do a lecture on a moving school bus? This way of positioning the role of art in relation to other practices has a lot to do with trust.

While Swintak took a sauna, my next studio visit arrives. It is Miguel Arzabe, from California. We used my portable generator to look at his past video work on the computer. I also gave him a tour, a practical, hands-on tour of the *Walking Studio* because he will be staying here when I leave. There was an enormous amount of care I took in this tour. It was not about the work per se, but the possibilities of it. I want him to have a great experience here and I am not sure why.

Next was the collective *Terrarea*: Janice Demkiw, Olia Mishchenko, and Emily Hogg. As the inaugural artists-in-residence, they had made an installation in the *Walking Studio* in early July when I had previously visited the studio with my Colombian artist-in-residence in tow. We talked about their experiences—how they treated the *Walking Studio* as a terrarea and therefore as a double frame for their own practice. Having the studio function this way afforded them the opportunity to be on the *inside* alongside their objects and specimens (some of which were found in the surrounding landscape). We worked on a text that they had due for an artist project by JP King at the WhipperSnapper Gallery called *The Free City Paper*. Fittingly, the resulting newspaper was constructed from a public invitation to contemplate and converse on the themes of waste, hoarding, labour, and art. This was not a top-down way of delivering "news" but a collective contribution to what constitutes it. Themes started to converge at the crossroads of two dirt roads where the *Walking Studio* was located. I couldn't help but think this was all just a big coincidence. Or perhaps themes emerged because I was immersed in these ideas myself? As in a mushroom foray, the closer you look, the more you see.

I changed it up a bit for the next artist, Justin Patterson, from Vancouver. Justin had a sauna *before* his studio visit. We sat there, him sweating in his underwear, me in a bathing suit, and talked about a number of his past projects that centred around themes of local labour and farming, projects like the one he did at the Art Gallery of Calgary where he created a grow-op in the gallery to cultivate barley and, together with the local community, made beer. He was attracted to *Don Blanche* because he grew up on a farm; his *untitled shed*, installed at the Red Deer Museum, was a public monument dedicated to farmers and the increasing disappearance of farmland.

As the sun started to set, I let the fire die down. I had one last studio visit, this time *inside* the sauna with recent OCADU grad Vanessa Rieger. We talked about how her experiences

at art school were completely incommensurable to her own working strategies as an artist. She found that art school was restrictive, isolated, and elitist. Art school promoted unhealthy power structures (and competition) while her work contrarily investigated practices that were open, responsive, and collaborative. She was really grateful for her experiences at *Don Blanche*, and, I think, for our conversation in the *Walking Studio* sauna. I invited her back to have another conversation in the sauna when it was installed at the AGYU. I'm sure Diane won't mind. I think the art students at York University could learn a lot from her, too.

* * *

Stepping out of the bush: a return to Toronto

As I complete my journey into and alongside Diane Borsato's *Walking Studio*, it dawns on me that the studio is just setting out on its own unconventional journey. I am but a small part of the larger arc of this work. While creating a record of the context of its first installation site, I am simultaneously using it, and this text, as a platform to highlight other artists' work with similar practices to Diane's. Years from now, I will look back on this text and remember my experience. And this text will potentially mean more to me than others I've written because the research process and writing experience has had a fundamental impact on *my* own journey as a curator. It has been really fun; the people I met were warm and welcoming, and my work dovetailed with other artists working there. I am thankful for having this unique opportunity to meet a new group of artists and for the things they have taught me while I was learning through Diane's work.

I look forward to greeting the *Walking Studio* again at AGYU where I will learn how to build it instead of how to live in it. It will be an entirely different sort of work at an art gallery but I know that my unconventional experience of it at *Don Blanche* will inform the basis of my understanding of it inside the gallery. While beautiful to look at, the *Walking Studio* is way better to *do*—and this is something I take away with me now to save for later. The stories I can share with gallery visitors won't be ones that a curator typically expounds to a tour group. My stories will be emotional and full of personal anecdotes. The personal is, after all, political.

It's time to leave behind the staid ways of talking about art from some abstract theoretical point of view that has little to do with either the artist's work or the curator's experiences of it. As curators/writers/interpreters/educators, our task is to move forward and develop practices that follow and mimic the principles and strategies of the artists that we work with. To find a way of writing that allows us to participate in an artist's work, rather than simply find words to describe it. For me, that's definitely a path worth taking and a territory worth knowing.

Notes

1. http://www.dianeborsato.net

2. Borsato has already left some clues to interpreting her work in her approach to artist's talks or public programs. Rather than simply describing her projects she makes the audience experience what her work proposes by putting them in analogous situations. The audience 'performs' a different task than usual in order for them to understand what's at stake in her work. For instance, for an artist talk at the University of Windsor, Borsato hired a contemporary dancer to teach the audience to tango, and, as such, participants had the—potentially discomfiting—experience of testing their own personal boundaries. For the AGYU's *Performance Bus*, Borsato hired the reptile educator and herpetologist Blair Watson to conduct an adult-oriented lecture on reptile species native to Ontario while on the sixty minute bus ride to the AGYU's opening. Watson brought a crocodile, turtle, skink, and two snakes that riders handled up close (and personal). *Snakebus* (2009) played on riders' anxieties, fears, and inhibitions while opening them to learn about these reptiles in intimate ways. This intimacy of touch (handling and touching reptiles) is a literal expression of the tangibility of knowledge Borsato pursues, especially in her recent interest in naturalist field research. Borsssssato!

3. This has as much to do with our learning behaviors as it does with our behaviors of learning, which has implications for looking at art, especially participatory, collaborative, or engaged relational projects. If the modes and methodologies of artistic inquiry have changed, our task as critics/curators/interpreters/educators is to change our own approaches to meet the unorthodox demands proposed by the work. In order to think through these practices, we must find a similarly engaged methodology: we must move away from traditional modes of observation to strategies of participation.

4. I like the idea of learning about one thing while studying something else. I started to think of my approach to Diane's work while coincidentally reading Tim Ingold's book on ethnography entitled *Ways of Walking: Ethnography and Practice on Foot*. I came across this book accidentally and in an entirely non-art related context but found it to be very relevant—more relevant, in fact, than any art text I've read recently—to thinking through engaged contemporary art practices.

5. In his introduction, Ingold writes, "A way of walking, for example, does not merely express thoughts and feelings that have already been imparted through an education in cultural precepts and properties. It is itself a way of thinking and of feeling, through which, in the practice of pedestrian movement, these cultural forms are continually generated."

6. Artist's statement for *Walking Studio*, 2011.

7. The books in the *Walking Studio* library are very much related to the work itself, more for the hobbyist than the art theorist: plant guides; cookbooks for wild species of plants; information about saunas, building shacks, and shelters, etc. They act as alternative guidebooks to the artwork. One of the quotes from D.C. Beard's *Shelters, Shacks, and Shanties: The Classic Guide to Building Wilderness Shelters* says it all: "no professional architects needed here; and knowing how to use an axe is more important than possessing carpentry skills."

8. The artists who run *vsvsvs* studied at University of Guelph, where Diane is an Assistant Professor.

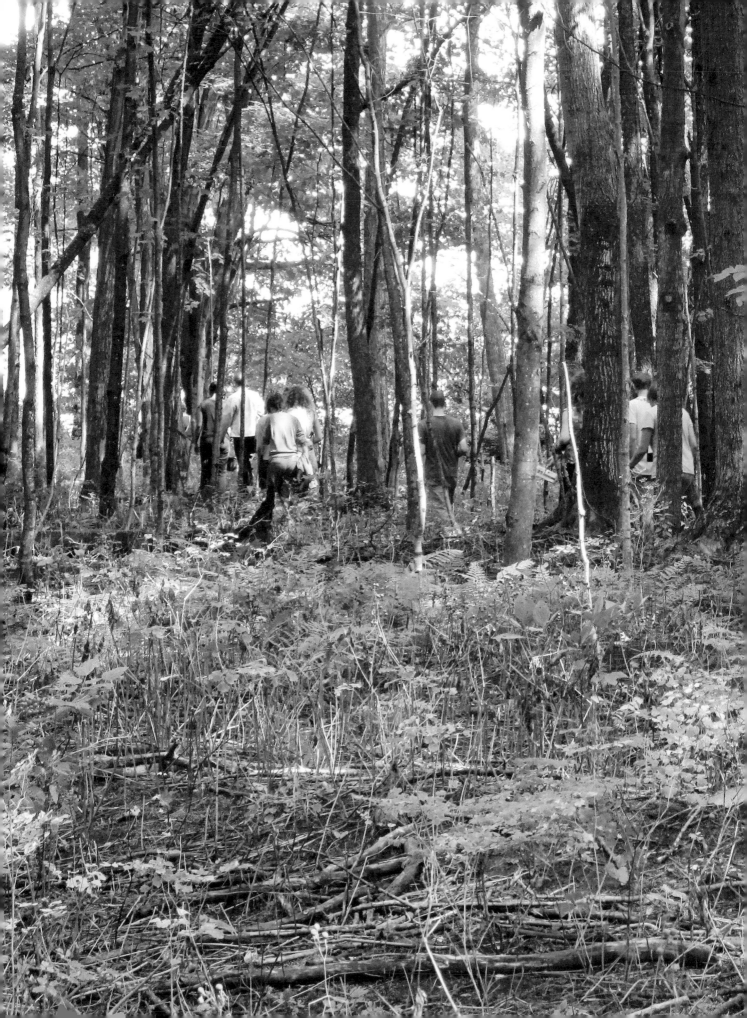

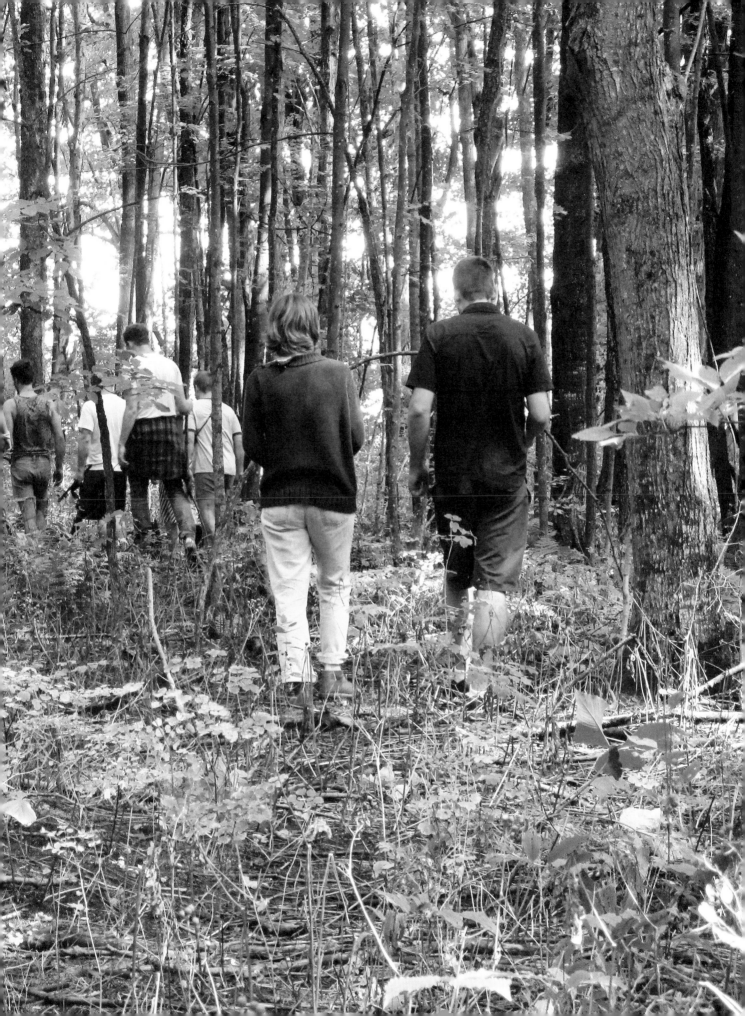

Biographies

Darren O'Donnell is a novelist, essayist, playwright, director, designer, performer, Artistic Director of Mammalian Diving Reflex, Research Director of The Tendency Group, and co-founder of The Torontonians. His books include: *Social Acupuncture* (Toronto: Coach House Books, 2006) and *Your Secrets Sleep with Me* (Toronto: Coach House Books, 2004). His best-known work is *Haircuts by Children*, which was first created in collaboration with the children of Parkdale Public School in 2006. In addition to his artistic practice, he is currently an MSci candidate in Urban Planning at the University of Toronto. **Mammalian Diving Reflex** is a research-art atelier dedicated to investigating the social sphere, always on the lookout for contradictions to whip into aesthetically scintillating experiences, producing one-off events, theatre-based performance, videos, installation, theoretical texts, and community happenings. Company members range in age from 13 to over 80 years old. Mammalian Diving Reflex's work has been presented around the world. **The Tendency Group** is an emerging think tank and social policy laboratory with three initial, but still fluid, intentions: 1) To develop community consultation techniques that acknowledge that oftentimes a community needs to be built before it can be consulted. 2) To develop affordable housing that includes the ongoing participation of artists who utilize social relations as material and whose vocation is the fortification and strengthening of the social sphere. 3) To include children in the urban planning process in a meaningful and material way, with input that is actually applied and implemented. Initiated by Sanjay Ratnan and cofounded with O'Donnell, **The Torontonians** is a Parkdale-based art collective ranging in age from 11–45, working as a division of Mammalian Diving Reflex. They create performance, give lectures, make videos, dance on the street, hassle drunk guys, take photographs, check cell phones, sing songs, play cellos, draw bunnies, take the TTC, ride bmx, and do volunteer hours.

Stephanie Springgay is an Assistant Professor in the Department of Curriculum, Teaching, and Learning at the Ontario Institute for Studies in Education at the University of Toronto, where she teaches courses focused on arts education, cultural studies, and curriculum studies. Before joining the faculty at OISE/UT she was an Assistant Professor in the School of Visual Arts and the Women's Studies department at Pennsylvania State University where she taught courses in visual culture, feminist theory and research, and curriculum studies. Her current research focuses on how cultural production (films, performances, contemporary art practices) create pedagogical spaces that facilitate, invite, and demand "unlearning" as a site of creative resistance.

Currently she is working on two interrelated Social Sciences and Humanities Research Council of Canada (SSHRC) grants on relational and interventionist art practices, and on the 'pedagogical turn' in contemporary art and art education. She has published widely in academic journals and is co-editor, with Debra Freedman, of the book *M/othering a Bodied Curriculum: Theories and Practices of Relational Teaching* (Toronto: University of Toronto Press, 2012) and *Curriculum and the Cultural Body,*(New York: Peter Lang, 2007) and the author of *Body Knowledge and Curriculum: Pedagogies of Touch in Youth and Visual Culture,* (New York, Peter Lang, 2008).

Scott Watson is Director/Curator of the Morris and Helen Belkin Art Gallery (1989–) and Professor in the Department of Art History, Visual Art and Theory (2003–) at the University of British Columbia. He is Director and Graduate Advisor for the Critical Curatorial Studies program, which he helped initiate in September 2002. Recent distinctions include the Hnatyshyn Foundation Award for Curatorial Excellence in Contemporary Art (2010), Alvin Balkind Award for Creative

Curatorship in British Columbia Arts (2008), the UBC Dorothy Sommerset Award for Performance Development in the Visual and Performing Arts (2005), and invitation to the UBC Chancellor's Circle (2005).

Professor Watson has published extensively in the areas of contemporary Canadian and international art. His 1990 monograph on Jack Shadbolt earned the Hubert Evans Non-Fiction Prize (BC Book Prize) in 1991. Recent publications include *Thrown: British Columbia's Apprentices of Bernard Leach and their Contemporaries* (Vancouver: Morris and Helen Belkin Art Gallery, 2011); "Race, wilderness, territory and the origins of the Modern Canadian landscape" and "Disfigured Nature" in *Beyond Wilderness* (Montreal: McGill University Press, 2007); "Transmission difficulties: Vancouver painting in the 1960s" in *Paint* (Vancouver: Vancouver Art Gallery, 2006); and "The Lost City: Vancouver Painting in the 1950s" in *A Modern Life: Art and Design in British Columbia 1945–1960* (Vancouver: Arsenal Pulp Press, 2004). Recent and upcoming curated exhibitions include *Mark Boulos* (2010); *Jack Shadbolt: Underpinnings* (2009); *Exponential Future* (2008); *Intertidal: Vancouver art & artists* (2005/06) at the Museum of Contemporary Art in Antwerp; *Stan Douglas: Inconsolable Memories* (2005/06); *Rebecca Belmore: Fountain* (2005) for the Venice Biennale Canadian Pavilion; and *Thrown: Influences and Intentions of West Coast Ceramics* (2004). He is presently researching Concrete Poetry for a series of publications and exhibitions.

Emelie Chhangur is an artist and award-winning curator and writer based in Toronto where she works as the Assistant Director/Curator of the AGYU. Over the past decade, she has developed an experimental curatorial practice in collaboration with artists. Recent projects include *The Awakening*, a three-year multi-faceted participatory performance with Panamanian artist Humberto Vélez; *no.it is opposition.*, an exhibition and two-year collaboration with Brazilian artist-curator Carla Zaccagnini; and the *Centre for Incidental Activisms (CIA)*, a radical proposition of gallery "in-reach," where participatory, activist, and research-based practices were emphasized over conventional methods of exhibition display.

She has published a number of texts which follow the principles and strategies of the artists she works with, such as the hybrid screen play and curatorial text *Mechanisms at Play: a genre bending adaptation of Oliver Husain's Hovering Proxies*; a song for the artist collective Fastwürms entitled *AGYU Flava: Learning to Play Donky*; and a performative text that mimicked the work of Blackfoot artist Terrance Houle entitled *Indian Givn'r*.

Chhangur is interested in how exhibitions and texts perform to create unique interpretative experiences as well as in finding ways to enact activisms from within an institutional framework. As an Assistant Director of a public, university-affiliated, contemporary art gallery, Chhangur believes that the contemporary art gallery must serve a social as well as aesthetic function. In fact, other than single channel videos and installations shown nationally and internationally, questioning the nature and function of a contemporary art gallery is her primary art project at the moment.

Artist's Acknowledgements

Among the many participants, performers and collaborators in the projects represented in this book, I would like to extend special thanks to Maggie Groat, Adrian Blackwell, Jane Hutton, Don Miller, Emily Hogg, Janis Demkiw, Olia Mishchenko, Swintak, Sandy Plotnikoff, Riccardo Borsato, Andre Gastaldini, Alessandro Leone, Sebastiano Di Prima, Alberto Casella, Pipo Privitera, Howard Trottier, Wayne Lyons, Daryl Thompson, Juliet Pendray, Alan Gan, Paul Sadowski, Gary Lincoff, Cara Spooner, Michael Caldwell, Evan Webber, Alicia Grant, Keon Mohajeri, Matthew Romantini, Eric Trask, Loretta Bailey, Blair Watson, Ryan Driver, Chris Curreri, Luis Jacob, Emilie LeBel, Janina Piva, Ryan Gibson, Amber Landgraff, Kristen Keller, Sarah Douglas, Alex Thompson, Alison Smith, Sky Fairchild-Waller, Danny Jordon, Allison Peacock, Julie Grant, Day Milman, Riaz Mehmood, Nadia Kurd, Liz Knox, Serena Lee, Alicia Grant, Nadia Halim, Andrea Roberts, Hazel Meyer, Joanne Hui, Stacey Sproule, David Blatherwick, Tatiana Melnyk, Lisandro Gomez, Mario Bruyere, Lisa Romaine, Toni Hrivnak, Joseph Baronka, Igor Rasic, Jennifer Leung, Robert Horvatek, Sergio Smilovich, Cynthia Loyst, Joel Silver, Stephanie Springgay, Kirith Borsato, Xavier Borsato, the Mycological Society of Toronto, the Vancouver Mycological Society, the New York Mycological Society, and the Royal Astronomical Society (Vancouver Centre).

I would like to gratefully acknowledge the support and hard work of the dedicated staff at the galleries and museums that hosted my projects. Among the many curators responsible for commissioning the projects in this book, thank you to Anne-Marie Ninacs, Jim Drobnick, Jennifer Fisher, Bruce Grenville, Vanessa Kwan, Eve K. Tremblay, Shaun Dacey, Nathalie de Blois, Frank Lamy, Michelle Jacques, Jane Hilton, Yael Raviv, Dave Dyment, Christof Migone, Helena Reckitt, Yvette Poorter, Sébastien Cliche, Erika DeFrietas, Kim Simon, Laurel Woodcock, John Zeppetelli, Nicolas Mavrikakis, Margaux Williamson, Craig Leonard, Rhonda Corvese, Christine Shaw, David Liss, Jeanne Granger, Gordon Hatt, Martha Langford, Ingrid Bachmann, Gisele Amantea, Mathieu Beauséjour, Kathleen Ritter, and Patrice Loubier.

For skilled photographic and videographic assistance, thank you to Amish Morrell, Nathan Saliwonchyk, Swintak, Dean Baldwin, Terrarea, Jesse Birch and Kim Munro, Edoardo Borsato, Alessandra Borsato, and J. Matthews.

Thank you to all of my generous teachers—my colleagues and students among them.

Thank you to the Art Gallery of York University, and to the contributors to this book, Stephanie Springgay, Michael Maranda, Emelie Chhangur, Philip Monk, Darren O'Donnell, Scott Watson, and Lisa Kiss and Jason Pare at Lisa Kiss Design.

Finally, I would like to extend my deepest gratitude to Mary Borsato, Mario Borsato, Amish Morrell, and Felix Borsato Morrell for the innumerable contributions that made these works possible.

I would also like to gratefully acknowledge the support from various funding organizations including the Social Sciences and Humanities Research Council, the Canada Council for the Arts, the Conseil des arts et des lettres du Québec, the Ontario Arts Council, and the Toronto Arts Council.

 Social Sciences and Humanities Research Council of Canada / Conseil de recherches en sciences humaines du Canada — Canada

 Canada Council for the Arts / Conseil des Arts du Canada

 Conseil des arts et des lettres Québec

ONTARIO ARTS COUNCIL / CONSEIL DES ARTS DE L'ONTARIO

TORONTO ARTS COUNCIL